# ME AND MY BIKE

## DONATO CINICOLO

## PORTRAITS OF A CYCLING NATION

CONSTABLE

Constable & Robinson Ltd
55-56 Russell Square
London WC1B 4HP

www.constablerobinson.com

First published in the UK in 2013 by Constable,
an imprint of Constable & Robinson Ltd

A copy of the British Library Cataloguing in Publication Data is available from the British Library

ISBN 978-1-47210-666-7

Printed in China

10 9 8 7 6 5 4 3 2 1

# INTRODUCTION

When I was asked to make this book I I felt as excited as a little boy. After all, I have been riding all of my life, and I know many cyclists and bike owners, so how difficult could it be to find around 100 of them to photograph?

As a digital dinosaur, my first thought was to use the internet to find some subjects. After a few hours of patient searching I had developed a splitting headache, and the conviction that there must be another way. I rang my friend Roy Scammell, a film stuntman who is extremely knowledgeable about bikes, to see if he would like to go for a walk along the Camden Lock canal towpath. It was Roy who had first enlightened me as to the beauty of lugwork and Reynolds tubing. Before going to art school I trained as a mechanical engineer, so I have always appreciated fine workmanship.

It was a bright autumn day and all was at peace with the world. We had only walked about 100 yards along the canal when I noticed a narrowboat moored near the lock, with a well-worn and rather undistinguished looking bike on its stern. My knock on the window was answered by a man called John Homan, wearing an old bowler hat and a wide smile. Once I explained my quest, he invited us aboard.

After much discussion of bikes and other things, I ended up on deck taking his photograph. This was the way forward! It was a lovely little adventure. On parting, he said to me "You should photograph my brother-in-law," and that led on to a day-trip to Essex.

On arrival there, I met up with Paul Reed, who showed me his main workaday Penny Farthing, and we

took several photographs on the local village green. Then he invited me to have a go. I'd come all this way, so it seemed rude not to try. So with Paul's help, I climbed up and was off, running free. I managed quite a long ride but then ran out of road, and Pennys need a huge turning circle. Luckily I just managed to go off road onto the grass and made it back safely to my starting point. It was glorious fun.

I had given my camera to Paul's friend, and he managed to get a few photographs of me riding his Penny. I later printed one as a postcard and kept it in my notebook wherever I went. This little image was a marvellous ice-breaker when I met someone who might feature in a good bike shot. It was the single, most useful item in my kit, as it could be counted on to make people laugh. My family were also greatly amused, and very helpful in my quest. My wife and daughter found me useful contacts; my son Leo (also a photographer in his own right) had built several road bikes while at Cambridge School of Art, and had many cycling friends who also offered their assistance.

It was Leo who directed me to Simon Barnes, owner of The Hub Café, which serves the best coffee in Hertfordshire. After a couple of hours of philosophical discussion and cycling chat, I left with a picture of him with his unicycle. Simon and I have become great friends and he too has helped me enormously. While making this book, I have made many other new friends, and met some extraordinary people. This is one of the wonderful aspects of being a photographer; it can be a great adventure of discovery. It's somewhat like going for a bike ride. You set off on your favourite machine; the air is clear, the sound is quiet, and the world beckons.

I was born in Italy, during the last century (yes, I am that old!) in San Bartolomeo in Galdo. It is a small, hilltop town so typical of Italy; narrow, granite-lined streets and many ups and downs. As a boy I was part of a gang of ragamuffins. One day we found an old, abandoned electric motor. We borrowed

some tools and spent hours taking the thing apart. We used the two motor bearings to make two wheels using a wooden axle. Then we incorporated the axle into a frame made from salvaged timber, and we had a simple scooter. We spent endless summer days clattering down the streets on this contraption. That was my first two-wheeled vehicle.

After my family relocated to the UK, I collected bits of bikes from the town dump and built myself an off-road bike. In my late teens, my good friend Phil Smee gave me a Freddie Grubb road bike. I regularly used that machine to visit my girlfriend (and later wife) Rosie, and I recall the bliss of riding silently down the streets at midnight, alone in the moonlight. Nowadays, I am more practical: I have a folding bike which I can use locally and have ridden while scouting locations in the past, as it fits neatly in the boot of my car.

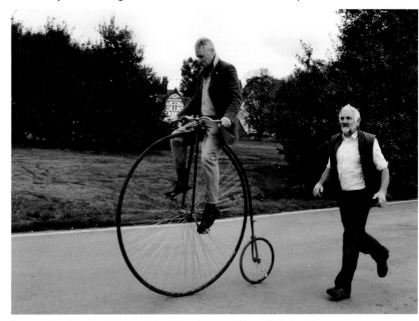

To all of the lovely, generous contributors who made this book possible; I wish you all well, I thank you heartily, and wish you all safe riding and God speed.

Donato Cinicolo.

# William Merrick Retired
*Peugeot 'Competition' racer, Shimano gears*

Dave, as he is known by his friends, was given an ex-WD bike for Christmas by his father when he was twelve. It was one of the lightweight folding bikes, originally designed to be used by paratroopers during World War Two, which were being sold off cheap in the post-war years. Dave's dad added mudguards and a few other 'creature comforts' and the bike became a much-loved means of getting about cheaply. Later, as an adult, Dave cycled much more and for longer distances, for instance on the London to Brighton ride. He recently took part in the Palace to Palace ride in aid of The Prince's Trust.

The rusty old exhibit on the left was bought from a junk shop. At the time it had blackout lights, as it had been used during the war. The bike was bought as an ornament, and relic of the past, and is kept by his front door.

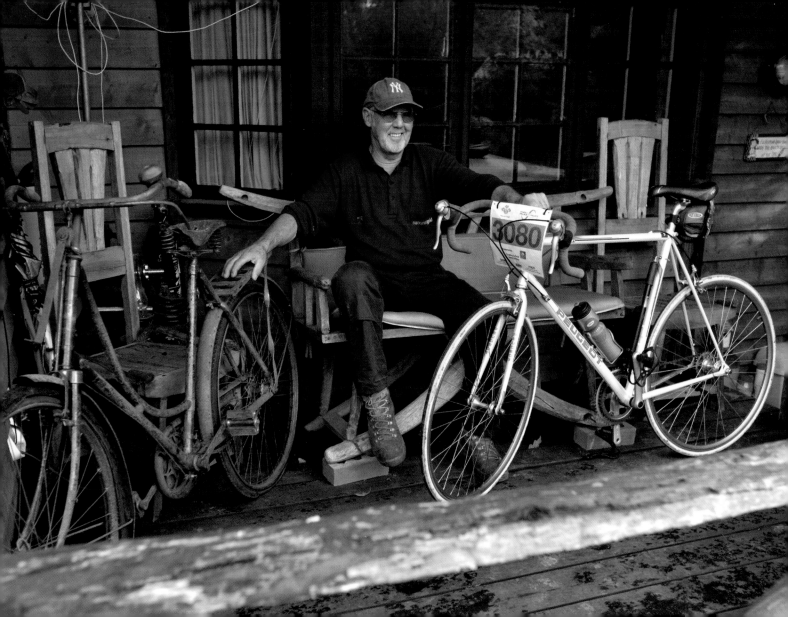

## Duncan Blom University graduate

*K2 Attack 2 Full suspension mountain bike (for cross-country and all-mountain use), 3 gears at front and 8 gears at rear, disc brakes*

Duncan was introduced to cycling at the age of 12 by two of his uncles, who were keen on mountain biking. He has always enjoyed using his bike for mobility, exercise and freedom. All of his family are cyclists and the house is always full of bikes, including some that belong to his friends. He currently owns three bikes: as well as the K2, he has a dirt jump bike which has a smaller frame and no back suspension and five gears; and what he calls a 'commuting' bike used for general town work. Duncan dreams that one day he might own an Orange 5 all-mountain machine, made in Britain. As he says "It's truly beautiful! Plus, it's designed exactly for the conditions we have in the UK."

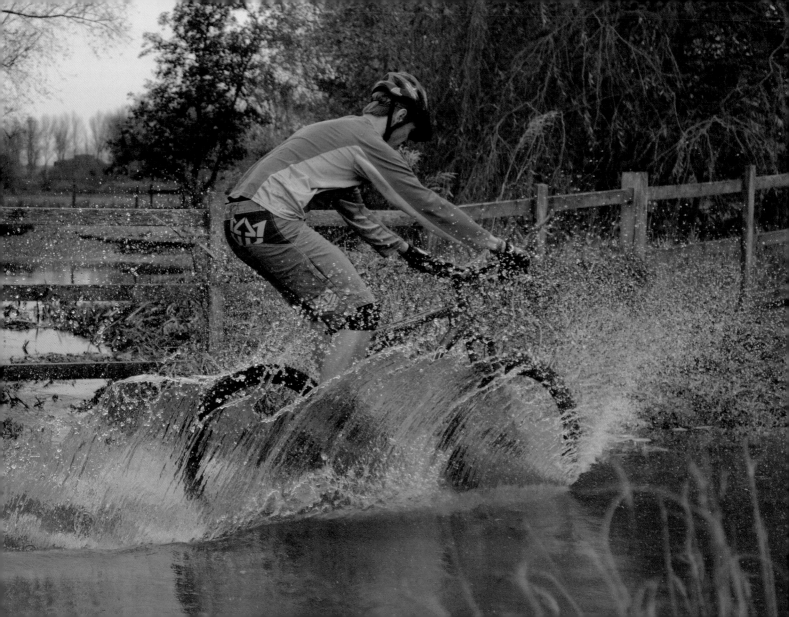

## John Homan Retired Electronics Engineer
*Townsend Team Elite mountain bike*

John bought his bike 12 years ago for £20 from an advert in his local newspaper. It was originally intended for his son, who wasn't interested in the bike, so John decided to use the machine himself, and to keep it on his boat. As the "victuals mule", anyone who comes aboard is free to use the bike for exploring, shopping, going to the pub and lots more. Although John hails from a landlocked town in Essex, he is addicted to life on the water, and adds "The bike is also useful as an emergency anchor, so I wouldn't be without it!"

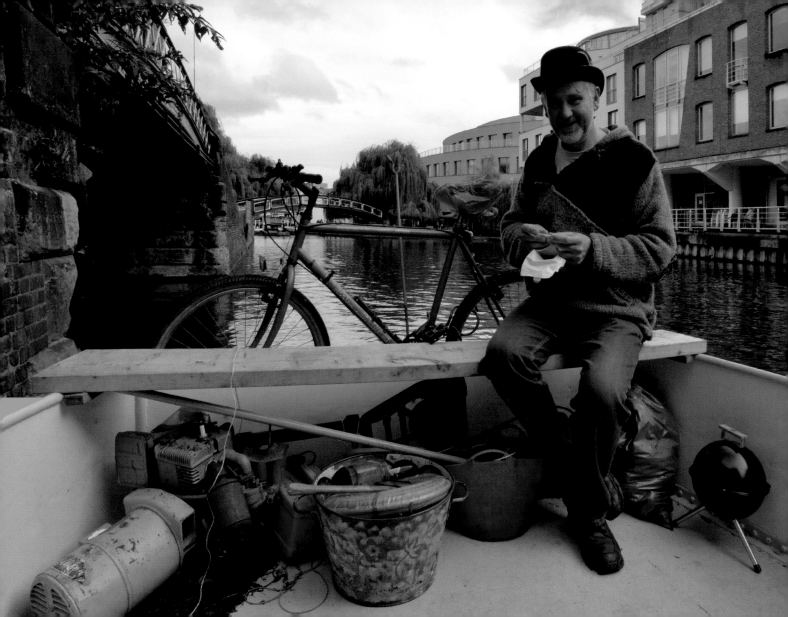

## Christian Ulf-Hansen Music Management
*Cudos Quadriga 4-wheel stainless steel racing rig, Sturmey Archer hubs/brakes*

Christian has always been keen on maintaining good fitness levels. One day he noticed an article about huskies and racing in a Sunday Supplement. He found it quite incredible, so he phoned the Kennel Club to find out more. Following that momentous decision he went on to attend some races and to meet up with racers in Essex. Inevitably one of the racers asked if Christian wanted a go, which he did. He ended up covered in mud but was immediately hooked. He put his name down for some puppies. He then bred his own huskies and now has eight in all. The dogs train for about 6-9 months and begin racing from about 12 months old. The racing season is Nov-March, with training taking place from Sept-April.

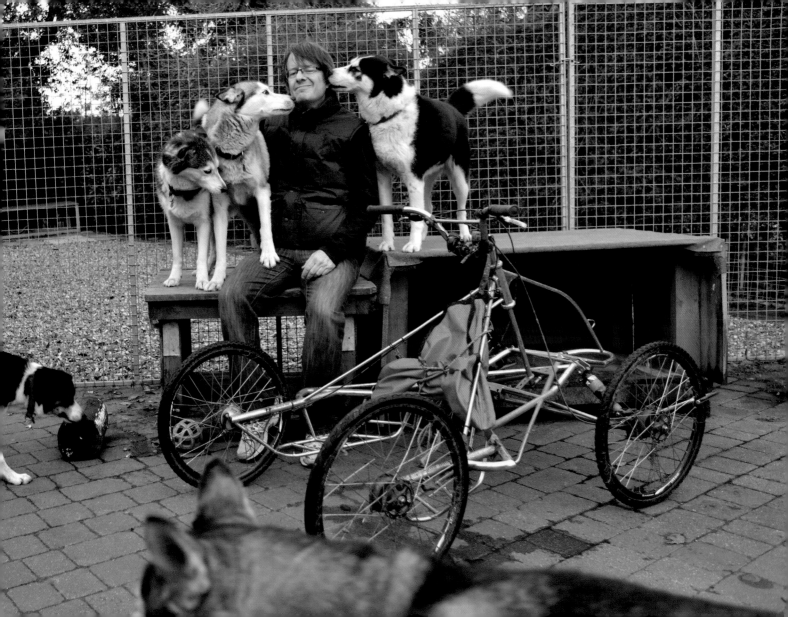

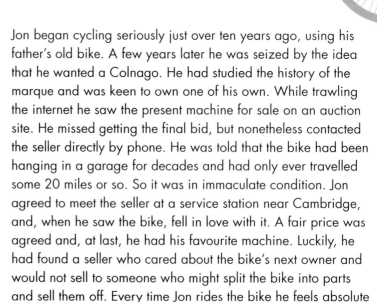

# Jon Willmott

*1982-84 Colnago Super/Mexico*

Jon began cycling seriously just over ten years ago, using his father's old bike. A few years later he was seized by the idea that he wanted a Colnago. He had studied the history of the marque and was keen to own one of his own. While trawling the internet he saw the present machine for sale on an auction site. He missed getting the final bid, but nonetheless contacted the seller directly by phone. He was told that the bike had been hanging in a garage for decades and had only ever travelled some 20 miles or so. So it was in immaculate condition. Jon agreed to meet the seller at a service station near Cambridge, and, when he saw the bike, fell in love with it. A fair price was agreed and, at last, he had his favourite machine. Luckily, he had found a seller who cared about the bike's next owner and would not sell to someone who might split the bike into parts and sell them off. Every time Jon rides the bike he feels absolute pride in this wonderful machine, which he can't imagine ever being without.

14

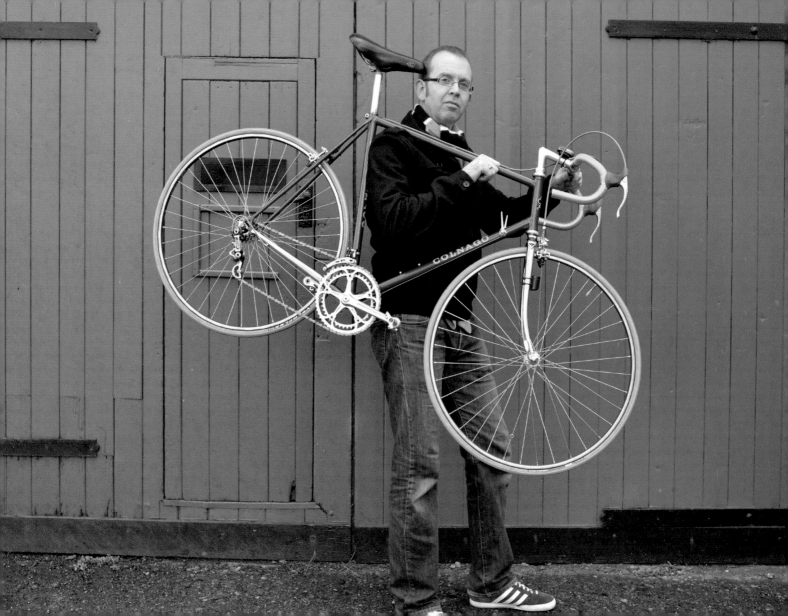

## Sara Pennell Company Secretary
*Ladies Dursley Pedersen 1903, 3-speed Dursley gears*

This bike was originally bought at auction in a terrible state of repair. After a complete overhaul, it was finally completed to its present condition, and is often used for riding about locally. In addition, Sara takes the bike to major shows all over the country, including the Benson Run in July. "It's a lovely, comfortable bike to ride," she says. Among aficionados, this particular model is reputed to be one of the best-engineered bicycles ever made. The saddle always seems to attract the most attention; it is made of over 140 feet of fine cotton piping cord (which needed staining with onion skin and tea leaves to achieve the right 'look').

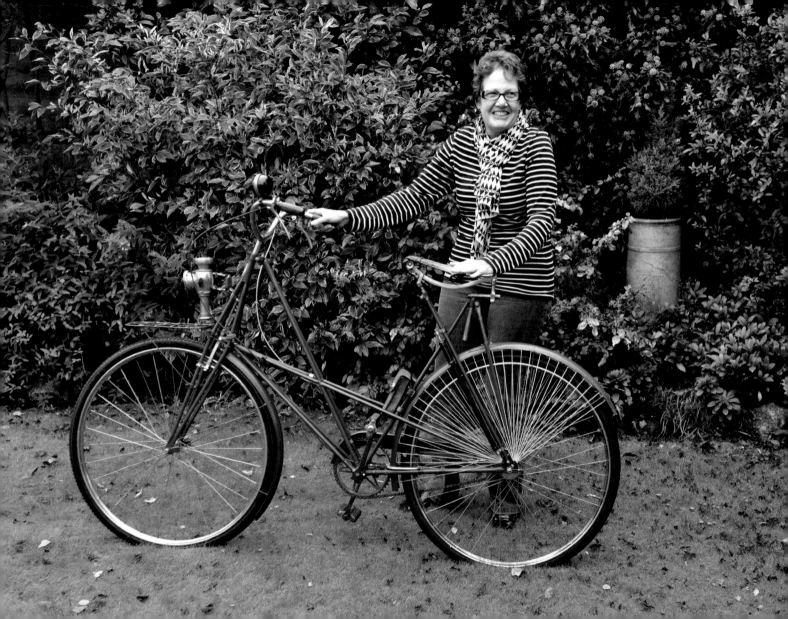

## David Smith Bike shop manager and former cycle racer

*Holding a bike which Bradley Wiggins used in a stage of the Tour de France and in the 2012 Olympics Road Race, regulation weight 16lbs, Pinarello frame with electronic Shimano wireless gears, Durace wheels*

David used to ride as a pro for about 30 years, and represented several companies. He was introduced to cycling by Max Pendleton (Victoria Pendleton's father). When riding professionally, he was given various bikes with which to race, so he had no particular favourite. For over two decades he has managed Hatfield Cycles where he looks after the needs of others, young and old. He enjoys the personal connection with riders, and his experience as both rider and mechanic comes into its own in this environment. The bike he is holding belongs to the current owner of Hatfield Cycles.

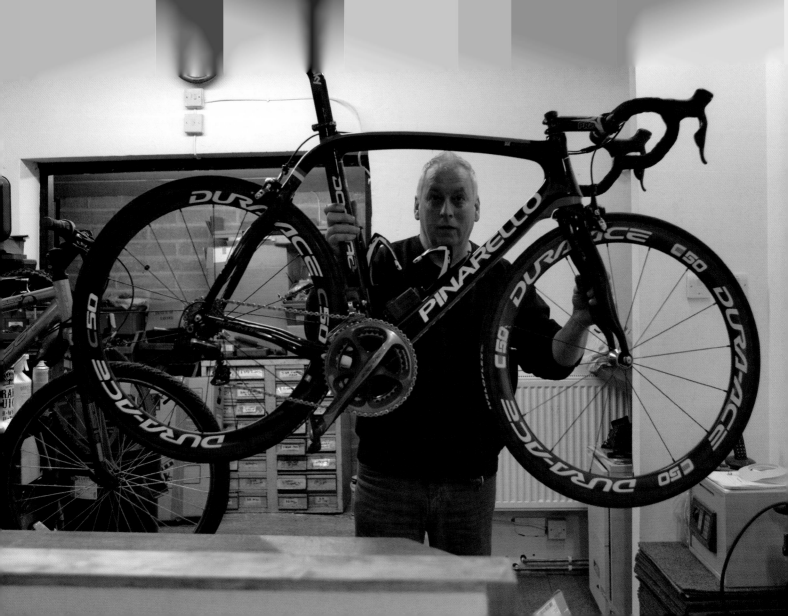

## **Simon Barnes** Explorer
*Pashley unicycle*

Simon's unicycle (or monocycle) has been in his possession for over three decades. He has ridden many bikes over the years, but he'd always had a yen for learning to ride a unicycle. Once he bought it, he found it extremely difficult to master. He was not taught by anyone, just learnt the hard way, on his own.

He got his first bike aged eleven, which he used to go to school and visit friends. It was a heavy bike, with a steel frame and rod brakes, and he found it hard going. Eventually, he saved up money from a paper round, managed to buy a frame, and gradually built up his stock of parts, enabling him to make a racer. He began to take riding increasingly seriously, and was eventually asked by GB Olympic Sports if his company could support the cycling event, to which he agreed. This led to the formation of a professional team (third division professional ranking). He still races from time to time as a veteran, and has taken part in the World Masters Track Championships. He has opened The Hub café, which is a popular destination for local cyclists, and which provides a repair and ancillary service for machines of all types.

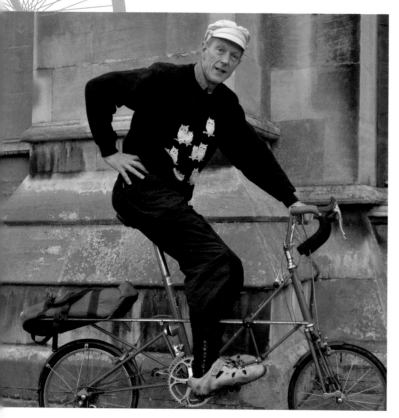

# Sir Peter Trevelyan, Bt.
Town & Transport Planning Consultant
*Moulton Jubilee 1984-5, 14 gears*

This bicycle was bought in the mid-1980s when Peter was engaged in some cycle planning research for the TRRL (Transport and Road Research Laboratory). As the bike is collapsible, he was able to carry it around Europe on trains. Most of the research took part in city centre cycle routes. According to Peter, "The Moulton is a 'proper' bike. It has a lightweight frame, is beautiful to look at and has suspension giving a comfortable ride." The bike and its owner have toured the UK, as well as making extensive trips around France. Currently, Peter uses his bike to cover over 1000 miles per year. In addition to the Moulton, there are various other machines in his 'stable' including a tandem, track bikes, and a trailer.

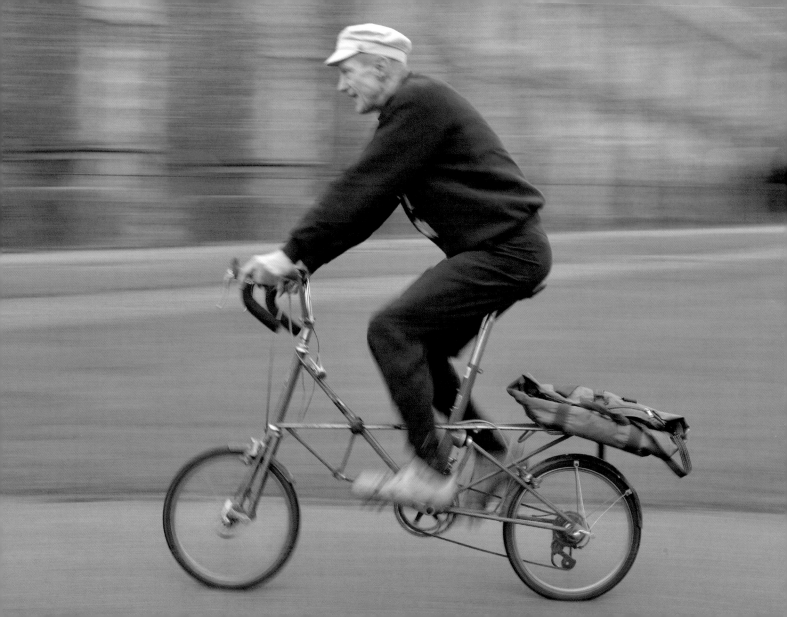

## Sian Brice Director and co-founder of 'Beatbike'
*Cannondale Synapse*

As a youngster, Sian lived on the Isle of Man and used to go everywhere on a bike. Later, at Oxford University, she cycled everywhere, like thousands of other students. She even brought her very own bike over from her home, via the train, to Queen's College where she studied. Sian was a runner while at university, and managed to land a track scholarship to the USA. She did a lot of mountain-biking in the beautiful countryside of Alabama. Later, back in Blackheath, London, she began working in the City, and took up triathlon. She won the National Triathlon Championship in 1996. She then gave up her job and took up training seriously, ending up at the Sydney Olympics in Australia, funded at the time by the National Lottery. She trained all over the world; in South Africa, in the Alps, Brazil, all over Europe, the USA, etc. She took part in an 'Iron Man' challenge in 1999. She has also taken part in a stage of the Tour de France. She says "Cycling in France is so amazing. Cars give you plenty of space. Everyone is always cheering you on. The feeling is wonderful."

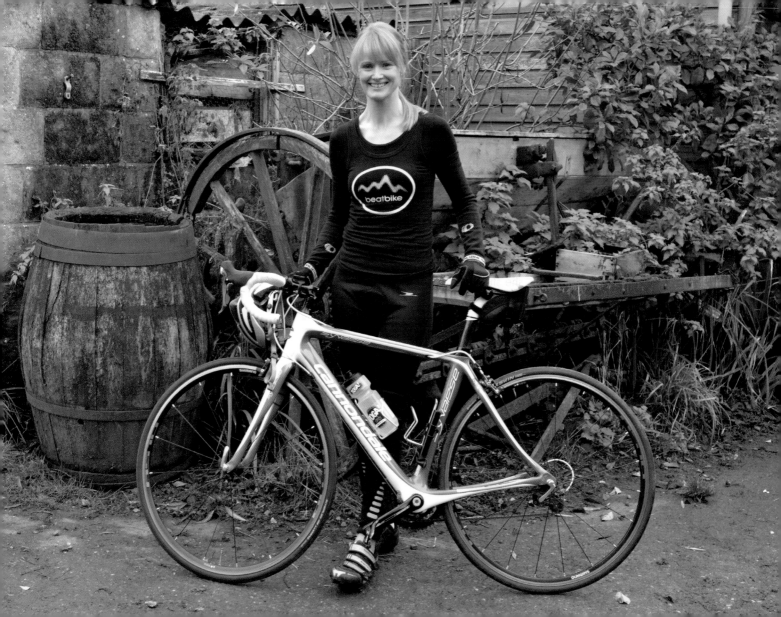

## Matthew Papa Social carer
*Hercules ladies bicycle, 28-inch wheels, 3-speed Sturmey Archer gears*

This bike was found abandoned with no wheels or saddle. Matthew contacted the Old Bicycle Company and had the correct parts sourced and fitted. It was originally intended for a lady, but Matthew has no reservations about being seen on a ladies' bike. He uses it all the time to travel about locally, where no-one gives it a second glance.

28

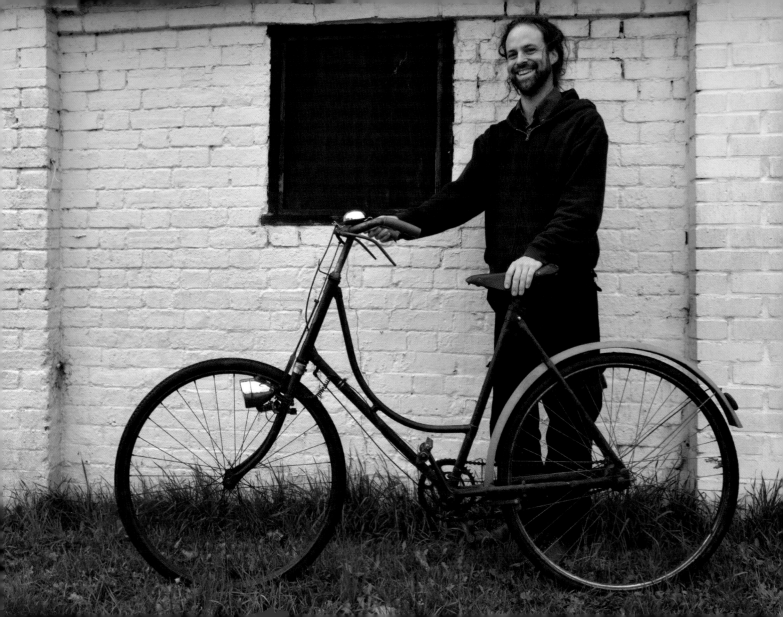

## **Alan George** Former Management Consultant
*Greenedge folding electric battery powered bicycle, Shimano gears*

Alan has always had an interest in cheap sustainable transport and low carbon solutions. He wanted something that he could use to get around in France, as an alternative to hiring a car. Once his children had grown up, the second family car was sold and he bought the Greenedge. The present machine has been in his possession for three or four years. His neighbour in France, a Dr Jean Gagnier, the Conseiller General, first introduced him to an electric bike. On trying it out, he was astonished how effortlessly it could sail uphill. After much research, he found a Cambridge-based company which had a shop in Camden, London. Alan fetched up at the shop and, after an alarming ride about the locality, bought the machine and brought it back home on the train. The bike has been back and forth to France about eight times, and has more than paid for itself in money saved.

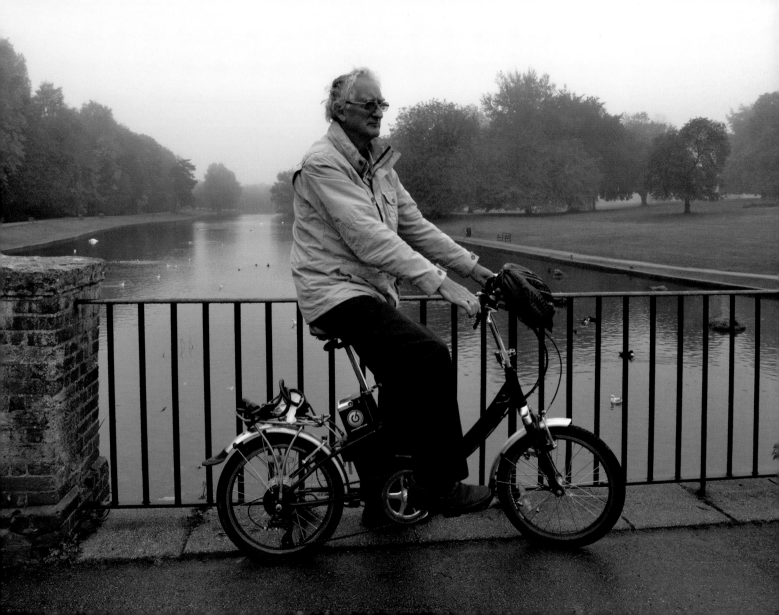

# Johnny
*Wishbone tricycle made in New Zealand*

The young man in the patriotic helmet has been riding the trike since he was 18 months old. The wooden machine is modular and can be gradually modified and converted to suit a growing child. Johnny learnt to ride inside the family home, graduating to the great outdoors: now he goes pretty much anywhere, especially down hills.

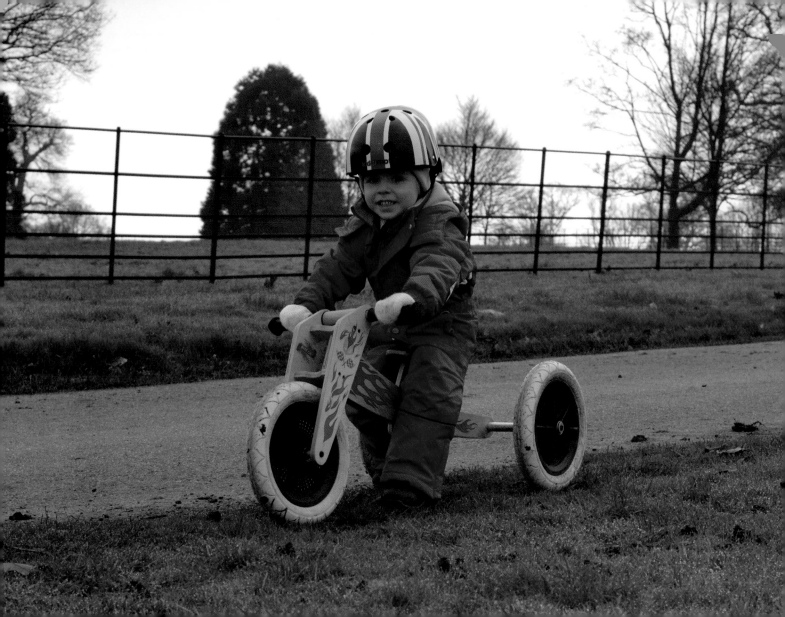

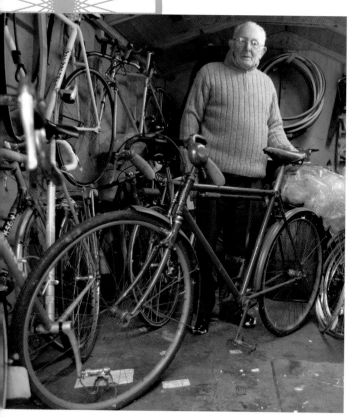

## John Lee Retired
*Bicycles: Selbach 1928 and Paris Galibier 1948*

John used to be in business with his father but when the business was sold in 1981 he had more time to go back into cycle racing. He has raced both the Selbach (left) and the Galibier (right). His uncle was a cyclist and young John naturally fell into cycling at an early age. In 1951 he joined the Icknield Road Club, eventually becoming President and life member. He began time trial racing in 1952 and won the club championship three or four times. He has eight national medals for various events. When he reached 80 he was the first man in the country to do the fastest hour on the open track, thus obtaining the national age record. He has also done 24-hour and 12-hour time trials.

John has always had numerous bikes. He repairs and reconditions them in his beloved shed. The younger members of John's family are not yet interested in bikes, "But that may change," he says with a smile.

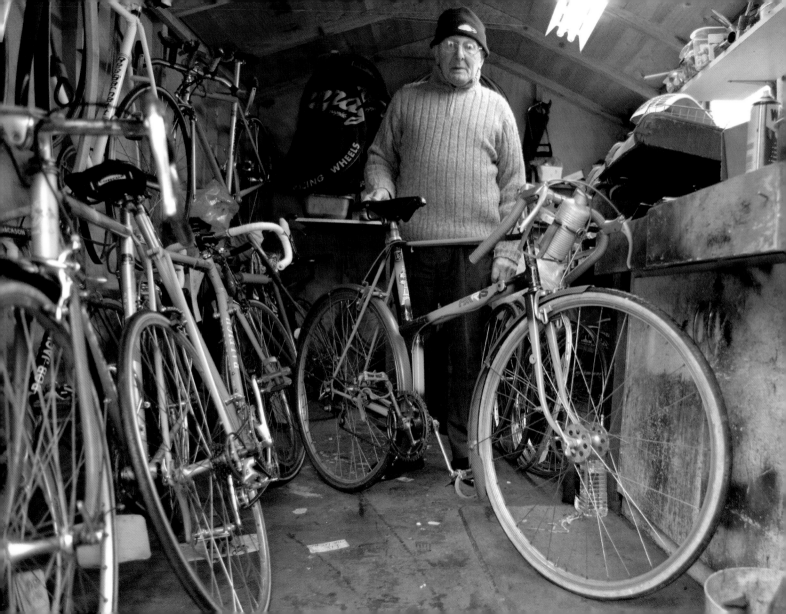

# Alexander Dowse Graphic Designer
*Tokyo Fixed Dart with carbon fibre forks*

Alex loves his city bike. It's simple, lightweight and doesn't attract too much attention. It is easy to maintain and good for nipping through traffic. His father used to race road bikes, so it was natural that young Alex would take to cycling. "At around seven years old I started dirt jumping and I found it exciting and exhilarating, even at that young age." As he got older he was persuaded to get a road bike, and often used to ride out with his dad and his mates. Then he began serious racing, which lasted for about two years, until he had a nasty accident which left him with a broken leg. Following a further accident, he left cycling alone for a while. Recently, he took it up again because it's so much fun and the easiest and fastest way to get around the city. Alex and his colleague have started a business designing specialist clothing for fashion-conscious cycling devotees.

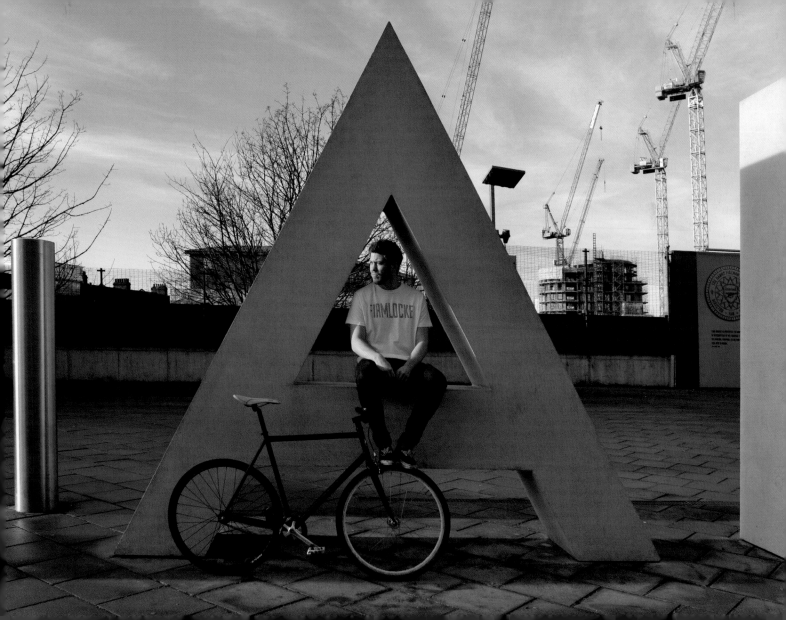

## Julian Pennell Retired Surveyor
*Gents Dursley Pedersen 1914, Dursley gears and Lea-Francis pedals*

Julian won the bicycle at a raffle in Bristol. He was attracted by the beautiful design of the machine, even though it was incomplete, having no saddle. He fitted a temporary saddle but, despite that, kept falling off since the bike was a rather large size 6. Using his knowledge and contacts, Julian managed to swap the original bike for a similar model at the smaller size 4, which suited his own build. Once the repairs were complete, the bike was finished off using specially mixed coach paint. Julian shows his bike at venues all over the country, including the prestigious Windsor Park Ride.

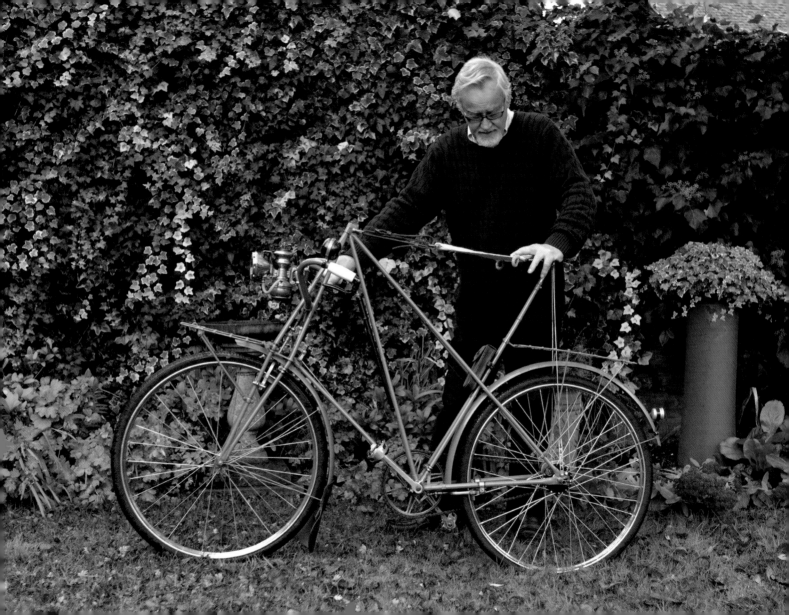

## Ben Walsh Professional bicycle mechanic and designer
*Prototype 26" Trials Addict trials bike*

Ben designed this bike himself and had it custom-built to his specifications, so it is unique. He has ridden in bicycle trials all over the country since he was 14, having fallen in love with the sport when he saw a school friend doing it over four years ago. He gained a lot of his practical knowledge working in various bike shops. This led on to him forming his own trials-bike-specific company, Trials Addict, through which he has met some of the leading experts and best riders in the UK. Many of his customers have also become good friends. He often comes fourth or fifth in the various local competitions he enters. He modestly suggests that his performance is 'OK' compared to his competitors.

## **Paul Reed** Farmer
*Penny Farthing, 56-inch wheel*

Paul's interest in Penny Farthings began when he was a teenager. He saw a Penny at a petrol station and asked the owner all about it. He was even allowed to ride it, but fell off rather badly. Nonetheless, he couldn't stop thinking about owning his own machine one day.

Eventually, about 20 years ago, he obtained his very own Penny; it was a Bailey Thomas machine. Of course, then there was no stopping him, and now he has four of them. He rides almost daily all around Essex, but has ridden his Penny in France, around London (which is pretty hair-raising at traffic lights) and takes part in many shows and races such as the regular one at Goodwood.

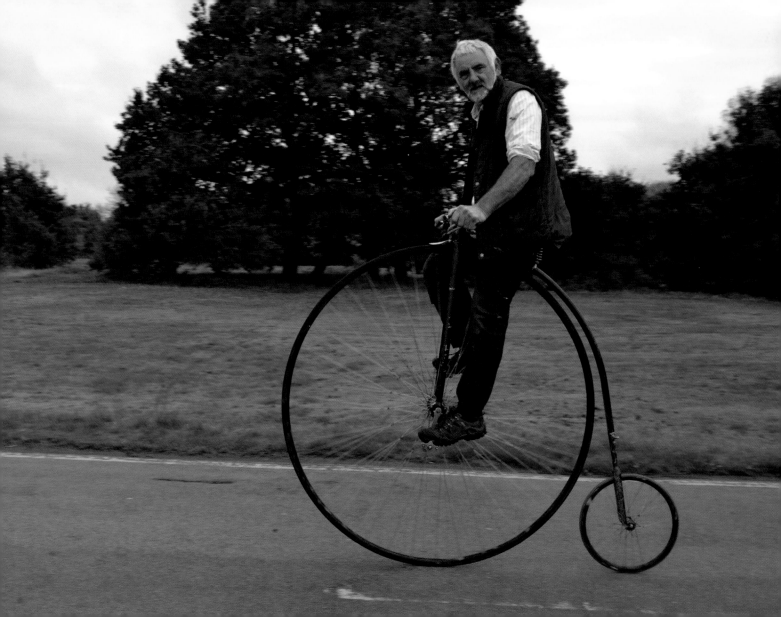

## Julian Trevelyan Chorister at St Albans Abbey
*Kraken Carrera mountain bike*

Julian has been interested in music since he was about five or six years old; coincidentally about the same time as he was introduced to the serious business of cycling. As a small boy, he remembers his father transporting him around in a trailer attached to his bike. As he grew up, he rode on the back of a tandem, and finally graduated to having his own bike. He doesn't have as much time as he would like for cycling, since his passion for music has rather taken over his life, with recitals all over the country.

## Peter Hunt Retired barrister
*Marin bike, Shimano rims*

Peter's very first bike, when he was five or six years old, was a 'Fairy'. He recalls that he found brakes rather hard to master, and kept smacking into hard objects! After a lot of moving about, mainly in Kent, he finally had a grown-up bike when he was ten: it was a second-hand Roadster with no gears and lever-operated brakes. By the age of sixteen, he often clocked up 100 miles per week.

He was involved with the Colonial Service in Uganda, during which time he had a Dawes bike, which lasted him for many years until it was stolen one day, never to be seen again. The inspiration to take up serious cycling came from Peter's father, who had a special lightweight racing cycle with split bamboo rims and a fixed wheel. On Peter's retirement from the Bar, he started cycling a great deal more, covering hundreds of miles in France. His favourite run is to cycle from St Albans to Berkhamstead, then on to Paddington along the canal towpath. One of his favourite ever bikes was a Claud Butler, which he bought when the 1970s petrol price rises forced many people to rethink their transport needs. He still has this lovely machine.

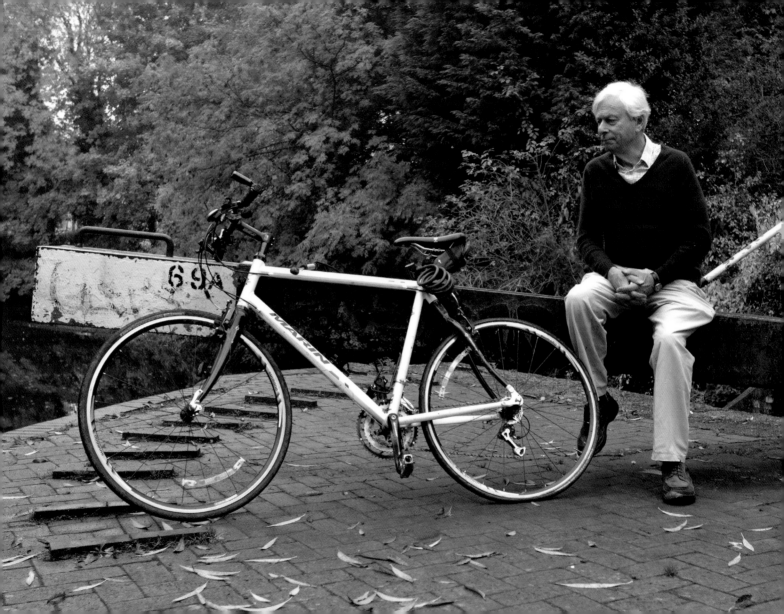

## **Bruce Sadler** Electrician

*Pre-war bicycle high stepper, 28-inch wheels, 3-speed Sturmey Archer gears*

Bruce collects and repairs old, and sometimes unloved, machinery. He is known in his locality as someone who "fixes things". The bike was given to him by a neighbour who knew that Bruce would be the right man for the job. In due course he repaired the machine and he uses it daily as a runabout. He is not precious about the look of the bike, and never bothers to lock it up when he goes to the pub, as no-one is interested in such a dour looking machine. He has several bikes, which get used in practical, everyday ways by him, his friends and family.

48

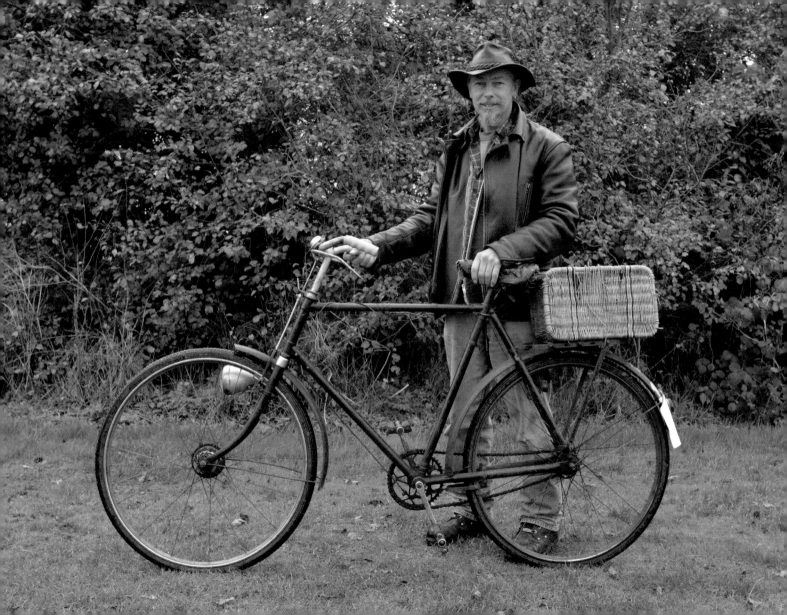

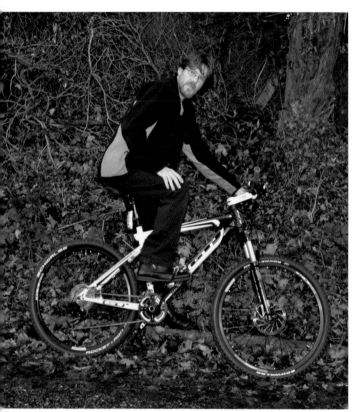

# John George Bryan

Bicycle mechanic

*1974 Raleigh Chopper, crossbar gear selector*
*GT Aggressor XC2 (right)*

John was the youngest of five children and always got the hand-me-downs from his elder siblings when it came to bikes. From about 11 onwards he began fixing bikes for himself and for friends and began to realise that he had a real talent for the job. Consequently he ended up going to college and getting an apprenticeship placement at Nigel Dean bikes. Since then he has been employed as a bike mechanic and also builds bikes from scratch, using his own highly specialised tools. For a while, he even had his own bike shop in Kent. He is currently building two Chris Boardman Team FS bikes, one from 2009, the other from 2012. He used to race all over the country, but a serious accident left him with several broken bones, so he has had to concentrate more on building and repairing. He is an avid follower of all things cycling.

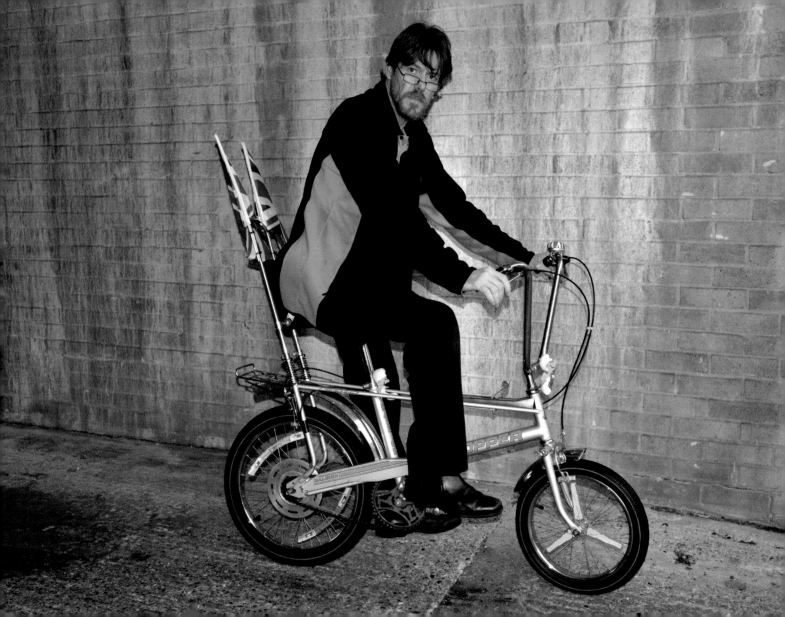

## **Les Peter** Banker

*Kona hybrid road/mountain bike, Shimano gears*

"I have been cycling mainly for exercise. It creates a bit of 'me time' and there's so many nice roads I can cycle on. I find it on the whole to be safe nowadays, motorists are much more aware of cyclists and generally give us a wide berth." Les has an office job during the working week, so he has to pack his fitness regime into the weekend. But he believes in keeping fit, so no matter what the weather, he is out as much as he can be. When he was younger, he used to run a lot, and competed in many marathons, but now he is a bit older he feels that cycling is far better all round exercise.

52

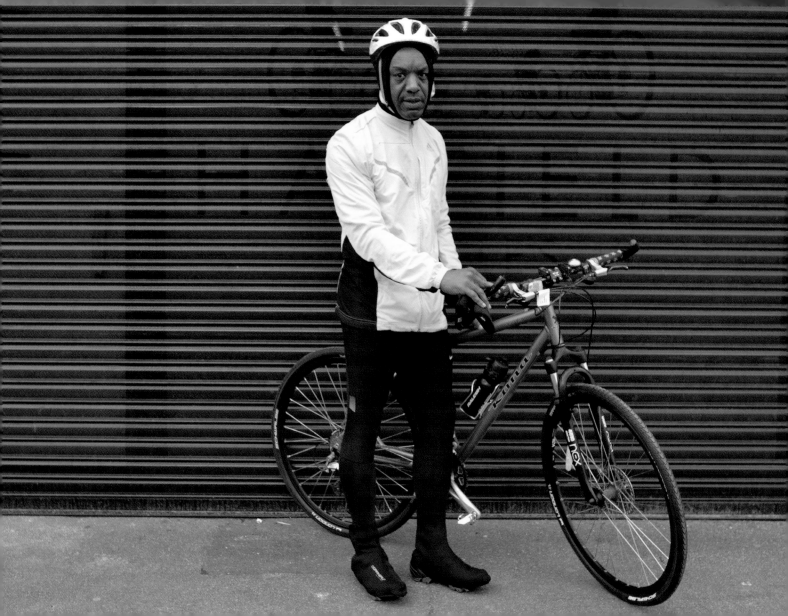

## **Lucy Pollard** Bike shop assistant
*Fixed gear "nologo" bicycle*

Lucy has cycled ever since she was little and was interested in bikes from an early age. She loves to be outdoors and sees cycling as the best form of exercise. Cycling has also given her mobility and independence. Her first bike was a purple Raleigh mountain bike given to her when she was 10 or 11 years old. Every day she cycles to work, but most weekends she is out on her mountain bike. She even takes her bike with her when she goes on holiday.

54

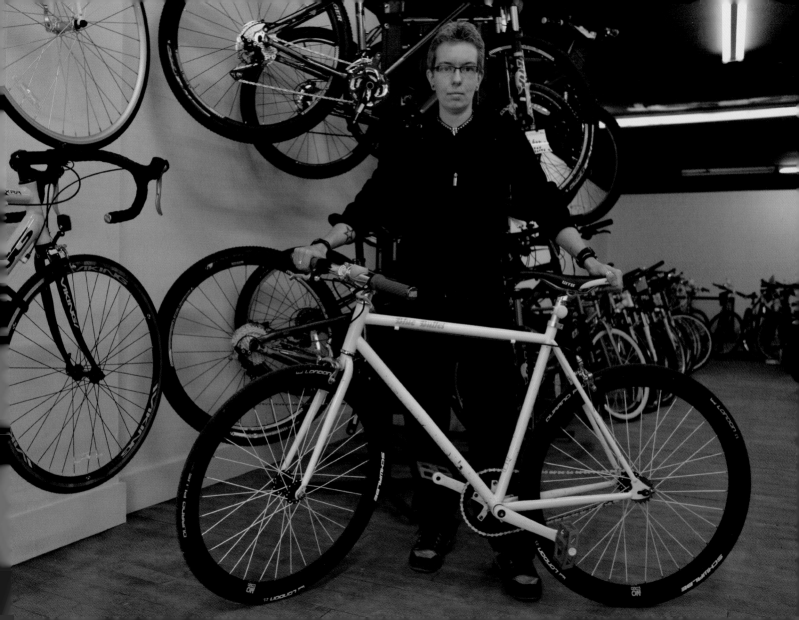

# Ben Pitts
*Specialized Rockhopper*

This bike was purchased through the 'Cycle to Work' scheme and Ben has had it for several years. The sizeable discount offered was too good to ignore. (The scheme allows employees to 'claim back' the tax against the cost of a new bike as well as to pay in instalments). Ben likes to keep fit; he is a snowboarder and surfer, and cycling is another string to his sporting bow. Given the choice again, he would probably have chosen some road tyres for the bike, as the off-road rubber presently fitted makes it hard going on roads. He particularly likes the fact that he can stiffen the suspension depending on conditions.

Ben grew up in a small Bedfordshire village, so bikes have been a feature of his life since he was a kid. BMXs were the favourites early on, then he graduated to more rugged mountain bikes; "I was always up in the woods," he says, "it was a great adventure exploring and riding with other boys." At present, he is considering adding to his collection by buying a road bike, but that's on hold, as he is moving house.

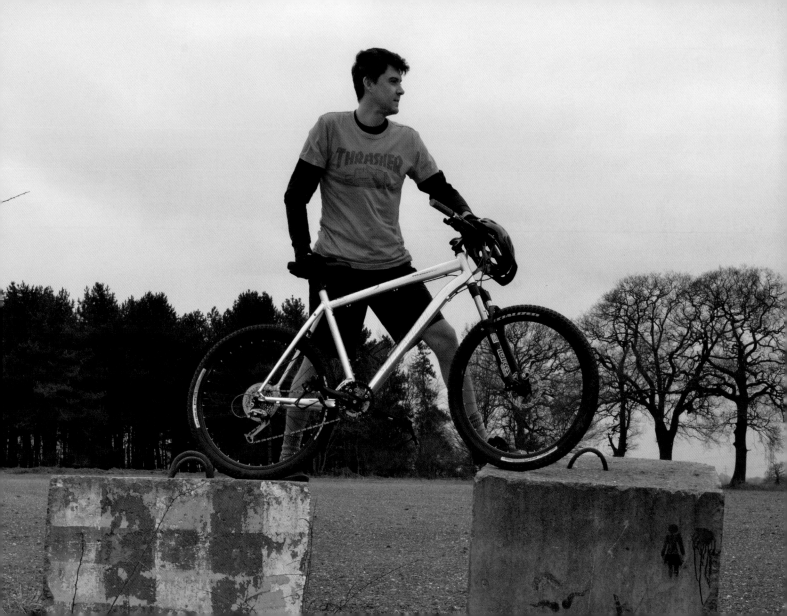

**Gerald Quinlan** Senior NHS Manager retraining as Psychotherapist
*Trikke electronic Pon-e from California*

Gerald was always interested in mobility and training and used to have a motorbike as well as a skateboard. A close friend of his, who was disabled, suggested the Trikke to Gerald, who was immediately fascinated. The only place which sold the machine was Rockit-Science, based in North London, so Gerald went over to try it out. He was impressed and bought one, which had to be especially imported from the USA. He uses the Trikke for shopping trips and for fun. Gerald observes: "Adults look at the Trikke in sheer disbelief. Children seem to get it straight away; they find it 'awesome' or some such cool word."

## Gerdi Quist Writer
*Koga Signature touring bike*

Gerdi looked at many bikes and manufacturers before deciding to buy her Koga, made in Holland. It is very strong and has a quiet modesty which is perfect for Gerdi's big trip, which she has been thinking about for almost 20 years, having been inspired by stories of lady travellers who made similar journeys in the past. She plans to cycle around the Black Sea area, a distance of almost 5000 miles, finally meeting up with her husband Chris in Odessa. The trip should take about three months in all.

Many years ago Gerdi travelled from Istanbul to Pakistan as a passenger in a van. She felt that she never really connected with the people in each country because she felt 'imprisoned' in the steel box. Although she saw wonderful sights, she didn't get to meet many people on a personal level. A rider on a bike is completely different as they can talk and stop and interact with anyone they meet along the way. Gerdi feels that she is ready to take on this great adventure and plans to take notes, photographs and write a regular blog about her experiences.

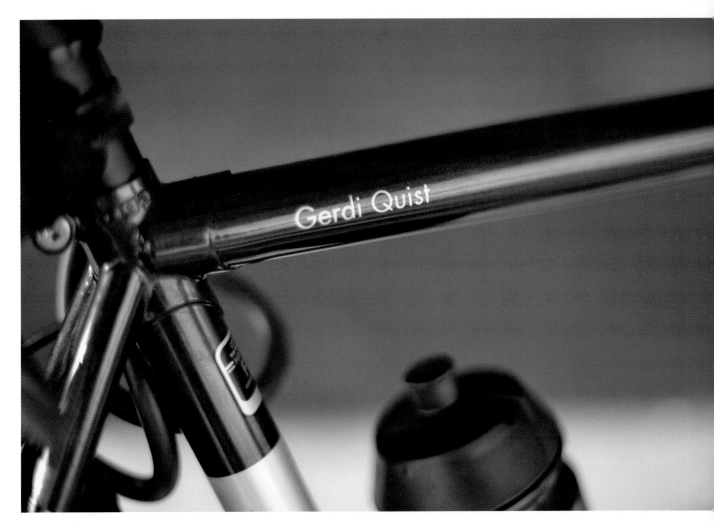

## Derek Titchner Retired Rolls-Royce Aeronautical Engineer
*Bob Jackson hand-built racer, Campagnolo gears*

Derek began cycling at an early age. At the age of 11 he was given a girl's bike because his mother thought that the crossbar was 'dangerous' and he learnt to cycle around Southgate, mostly on the pavement. During the war, he was given a second bike, painted red and called 'the scarlet runner'. This he duly wrecked by turning in front of an oncoming car. Luckily he was not badly hurt. When he passed the 11 plus, his father gave him a hand-built Stevens bike so Derek joined a Cycle Club. Unfortunately that bike too was smashed up. Over the years, he began to take racing seriously, even winning some medals. He obtained a 'first category' licence and raced with some of the best cyclists in the country. While he was in the RAF he was selected to ride the 540 miles of the Five Day Bicycle Race, in which he came 7th. One of the competitors was Fred Cribbs who later rode in the Tour de France. Derek's current Bob Jackson bike is made from Reynolds 531 Ultralite steel tubing, it has hand-finished spearpoint lugs, some of which are chromium-plated, and the frame is adorned with gold coachlines. The bike is fitted with Campagnolo gears, pedals, brakes and hubs built to his own specifications. The saddle is a Brooks hand-made professional saddle. He says, with some pride "The bike is admired wherever it goes, and I shall never to part with it."

64

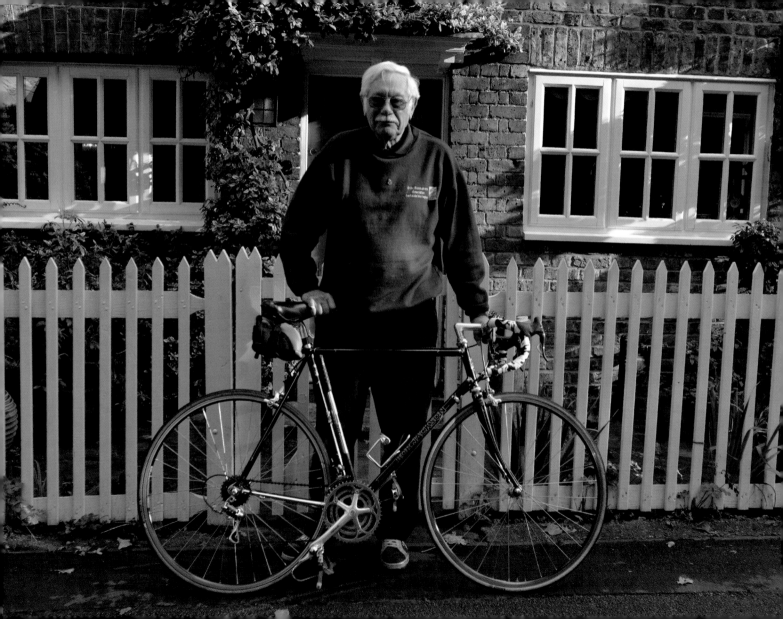

## Ozgur Yesilyurt London rickshaw taxi
*Orange pedicab*

Ozgur came to Britain after a period of study in his native Turkey. He has been working as a rickshaw cabbie for over six years. It gives him great opportunities to learn English at a practical level. He was introduced to the job by one of his family's friends who lives in London. Although the centre of London is reasonably flat, it does require a great deal of stamina to pedal a heavy machine containing two passengers "Especially if they have been eating too many hot-dogs!" adds Ozgur.

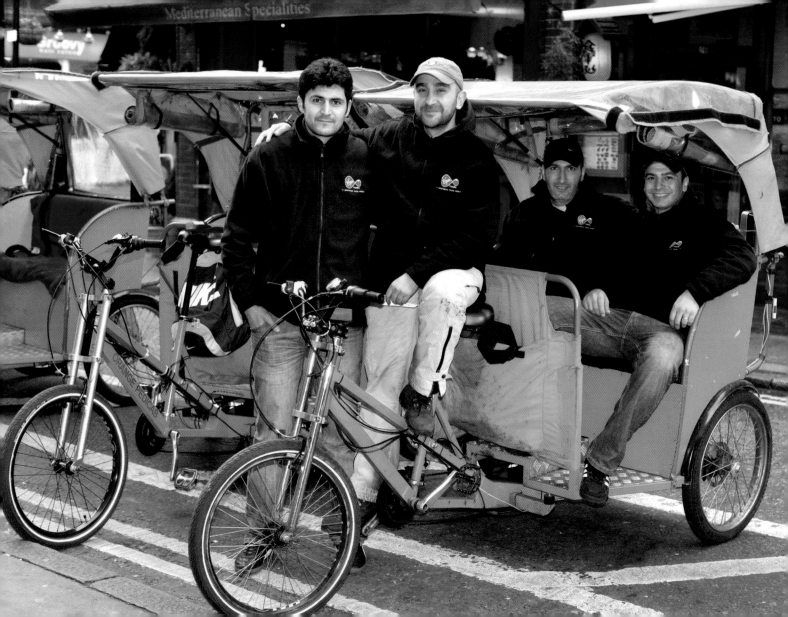

# Bill Sibley Retired bicycle shop owner
*Giant Defy 3, 27 gears, all-purpose bike*

Bill's grandfather had a bicycle shop and hardware stores, which was handed down to his father, who ran it all of his life. Bill inherited the shop, so he has bicycles in his DNA. His first bike was a 1904 Pedersen. He has been involved with the local cycling club since 1951 (he is now 77 years old). He has toured the Isle of Man and the Isle of Wight, as well as making regular local forays. He is also hoping to do Land's End to John o'Groats. He bought his present bike from the local bike shop, where he still works. It suits his purpose and purse very well. Bill adds "I was told a long time ago that the body is made to work. I hope to keep mine working as long as I can!"

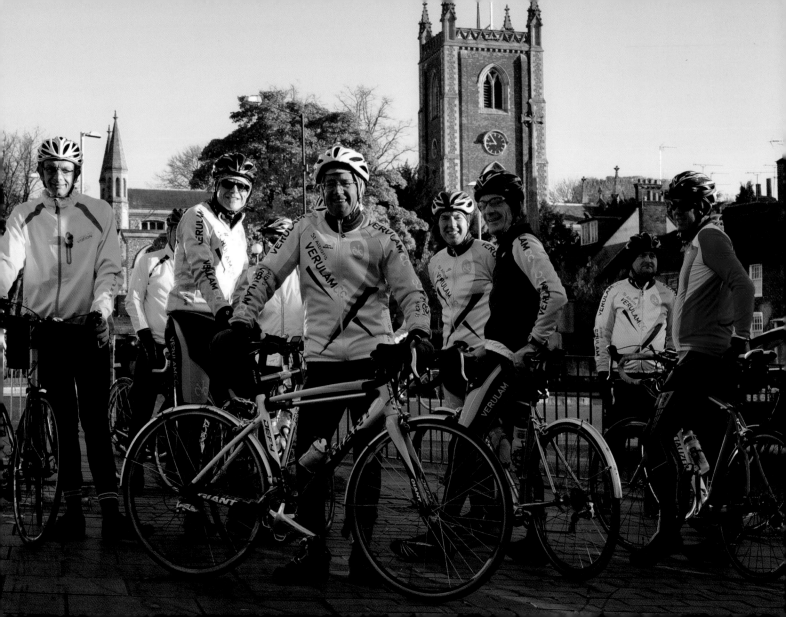

## Darrin Jenkins and daughter Isabelle Photographer
*Mercian 'King of Mercia'*

Darrin and his daughter Isabelle, who owns the Evans 'Cougar', are pictured while out for a ride together. Father and daughter have often done this since she was little. Darrin has been cycling since the age of three, and has never been without a bike. When he was four or five he used to cycle to the next village, quite an adventure in those days. As a teenager, he used to ride around Hertfordshire and Bedfordshire, exploring the countryside and little lanes. He has not done many long-distance rides, but he has ridden to York and back, toured around Wales, and once, with his wife, he cycled around Malaysia for a couple of weeks. He had his present bike made to measure because he was fed up with seeing the same old makes available commercially, and wanted something out of the ordinary, made specifically to his own measurements. After extensive research in magazines and online, he chose a frame-maker and had the bike made. Having ridden the machine over thousands of miles he feels very happy with his bike, and will never part with it.

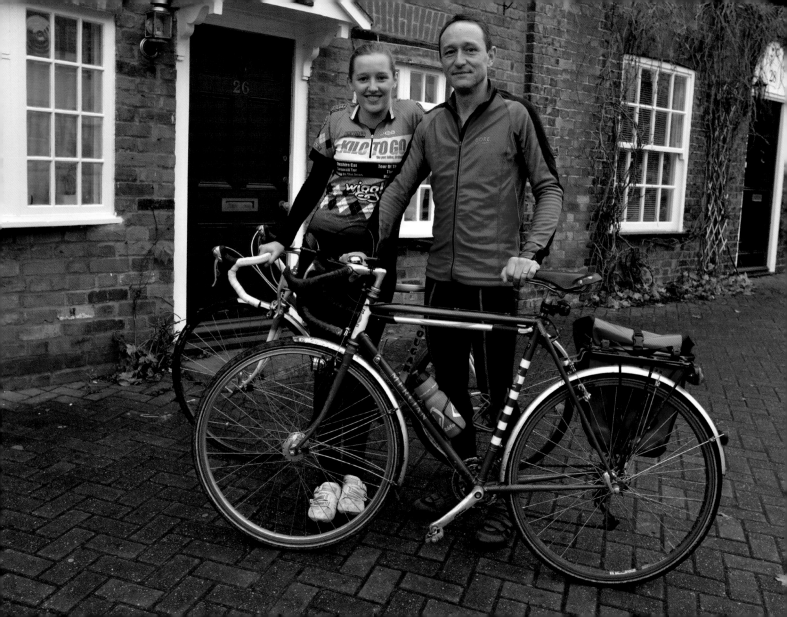

## Ian Gow Bike shop technician
*Mercian road bike*

"I have always liked bikes and, when I became a father, I sort of fell into cycling." Ian says that his children wanted to ride so he began taking them out and his interest grew with them. His daughter was especially keen so they used to ride around the country lanes together. One day she said "Dad, what about going out on an all-day ride?" So they chose some routes, and ended up doing the occasional charity ride. Eventually, he joined the local cycling club, even though he wasn't sure if he would be able to fit in. He also began collecting old bikes and studying their history, which he found fascinating. After a few years, the collecting got out of hand and he ran out of room for all the machines. So he sold off the less important bikes, keeping the best few for himself. He rides these from time to time. He particularly likes collecting the beautiful period components to go with the machines.

72

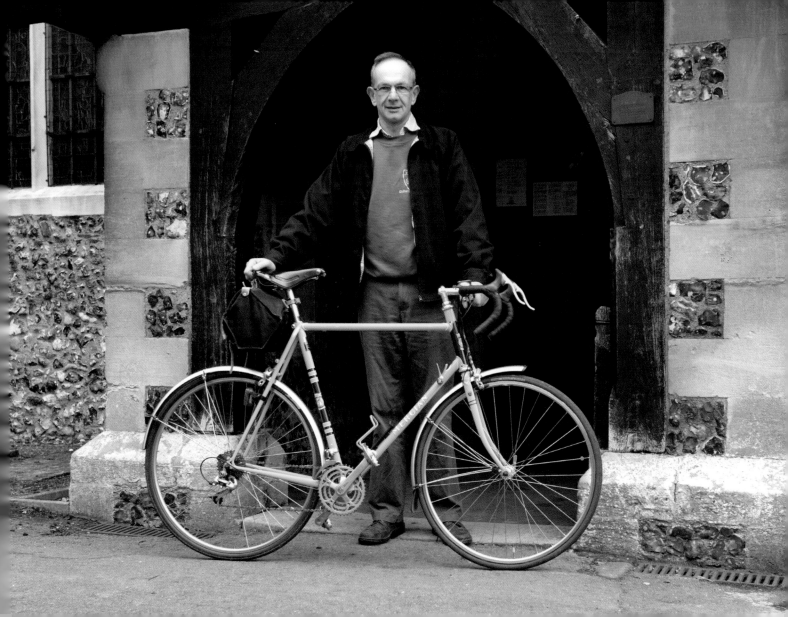

## **Melvyn Teare** Computer Studies Tutor
*Baker's delivery bike*

Melvyn's first experience of this kind of bike was when he was a young teenager, and had a part-time job delivering bread and groceries. This machine was bought over a decade ago, when he was City Centre Manager for St Albans. He used it to transport leaflets, brochures and other marketing aids around the town. In addition, he could set up an impromptu mini-exhibition stand which attracted attention wherever it was set up. He rode the bike in the Summer Carnival in its first year, as part of a bike parade. The bike was made by a company in Sussex which makes and refurbishes old bikes of this description.

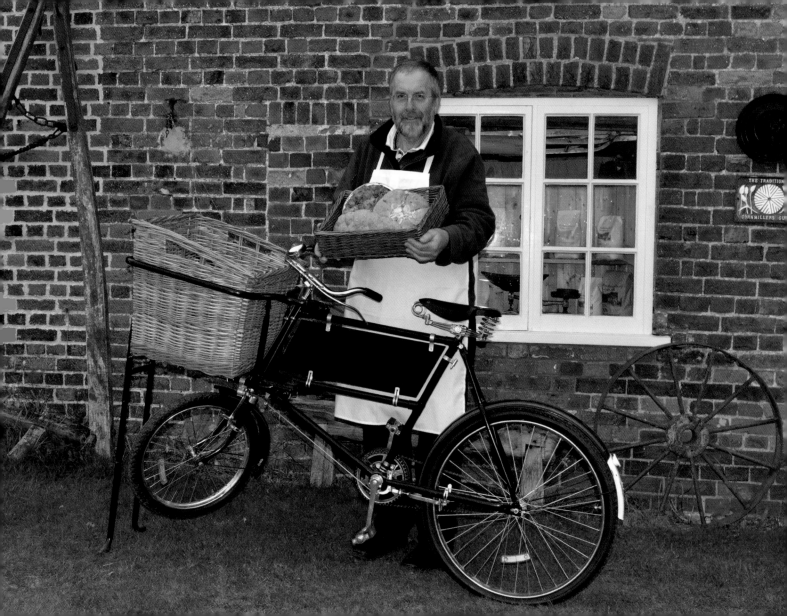

## Victoria Robertson Director and co-founder of 'Beatbike'
*Blue ACL*

Victoria grew up in rural Northern Ireland. She was part of a group of youngsters for whom cycling represented freedom of movement. She used to visit her cousins or grandmother with her bike, but she never really considered cycling as a sport. In later life, she moved to New York and became interested in indoor cycling, or 'spinning'. When she decided to move back to Britain her husband suggested that Victoria buy a road bike so that she could carry on cycling back at home. She was in New York on Memorial Day with her family when they came across a bike shop in Harlem. On impulse, they went in, meaning to just look around. Even though it was quite expensive, Victoria came away with her gorgeous bike that afternoon, and proudly rode it back to Manhattan. She went on to cycle the bike all over the city and Central Park, and from that day on, she used every opportunity to cycle.

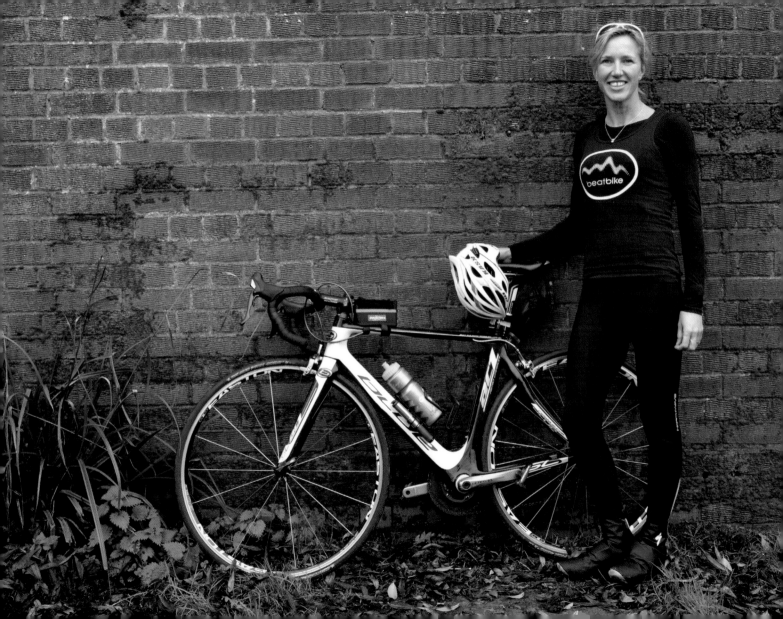

## **Damien** Garlic and Onion Seller
*French Postal Service bicycle*

Damien was born in Brittany, and every autumn he makes the trip to London to sell his region's finest garlic, onions and shallots. He has been doing this for several years now and, although he sells in various areas of the city, his favourite spot is in Hampstead. Damien admits "The weather is not very predictable, but I love the English sense of humour. Everyone smiles and is so friendly. I guess it's the Breton hat!"

The bicycle was a French Postal Service model, and, as such, has an extremely strong frame, well used to carrying heavy weights. The colour scheme is unchanged from the original, making it instantly recognisable, and a real icon.

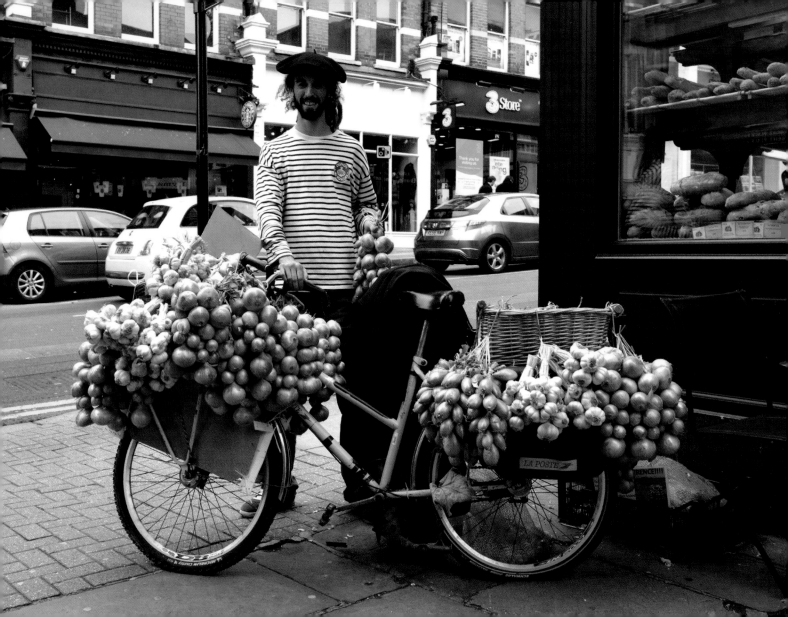

## PC Phil Snook Police Officer

*Fully marked up Police bicycle, Carrera 7005 T6*

The bike Phil is holding was supplied to the Hertfordshire Neighbourhood Teams as the Chief
Constable is a keen cyclist. A police officer on a bike is much more approachable as well as being
able to go more or less anywhere. The bike is a really comfortable ride, as it has suspension on
its front forks, as well as 27 gears and front and rear disc brakes. Phil has been fully trained in its
potential uses, for instance riding down steps and being able to make the best use of the bike when
chasing suspects. The bike is fully fitted with tool kit, high-vis police ID and Phil wears special protective
clothing and gloves. He has been in the Police Force for 26 years: it's ironic that when he first started
as a young constable he was also issued with a bike; although it was very basic and heavy to ride.
Phil likes this style of policing, as he can have much more direct contact with members of the public,
and it keeps him fit.

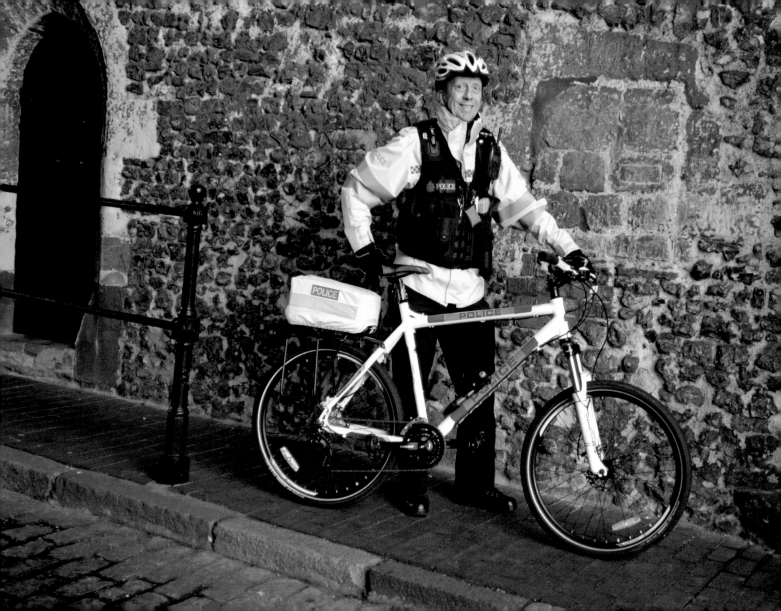

## **Paul Hayes** Group Finance Director
*Wilier Triestina Mortirolo carbon fibre bike*

Paul became interested in triathlons over five years ago and bought his current bike for this purpose. He had had several machines before, mostly mountain bikes, but when he saw this Wilier he was "talked into having the best". Having used it for several years now, he has become more passionate than ever about cycling. Paul used to live in Leicestershire and did much of his early cycling on the mountain bikes. Later, when he moved nearer to London, his thoughts turned to competitive sport. His wife and young family are all keen cyclists, and go on cycling holidays abroad. It's a perfect way for families to get into a regular keep fit regime and leads children to grow up thinking that it's perfectly normal to think about health and fitness.

It was Paul's wife who encouraged him to think about triathlons, and cunningly spread the rumour that he was up for it. When friends began saying "Well done, we hear you've entered the triathlon" it seemed churlish to back out! Now he loves the sport, and would not think of going back.

82

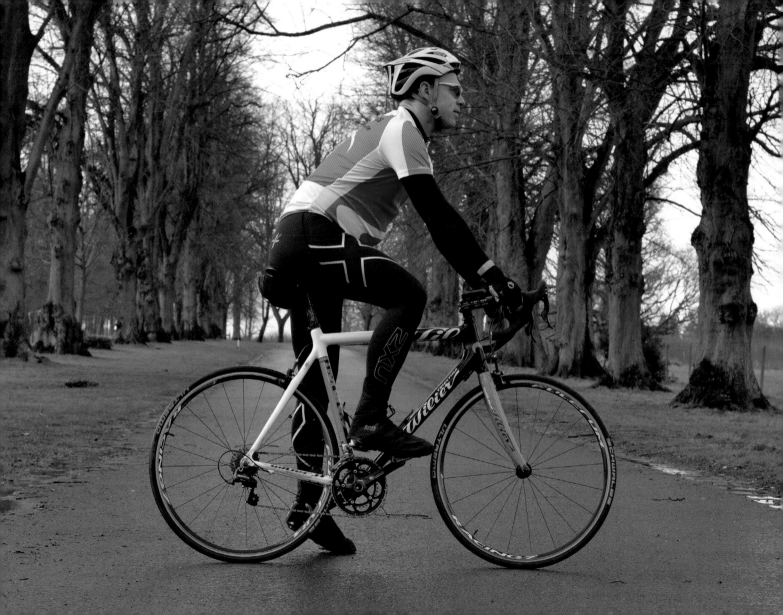

## **David Coombes** Retired postman and horseman
*Giant Express n7 road and track bike*

David's first experience of freedom and mobility came when he was given his first tricycle, as a small boy. When he was a little older, his father bought him a second-hand bike which had been 'knocked together' from bits. When he was about 14 he bought his own bike from savings he'd amassed from a Saturday job. He bought this machine from a shop run by Stan Miles, who was a champion cyclist at the time. Eventually, David got a job with the Post Office and was given a 'GPO bike'. He used to do two rounds a day with the mailbag perched on the front. It was hard work, especially when Christmas came, as each round was a few miles long. The bike was very solid, with no gears, so pedalling was hard work. In addition to all of this cycling, he used to cycle to work on his own bike. It's true to say that he has never really been without a bike. He has also had horses all of his life, but says he will never give up cycling: "Horses can sometimes be moody; they all have individual characters. A bike, however, is very dependable!"

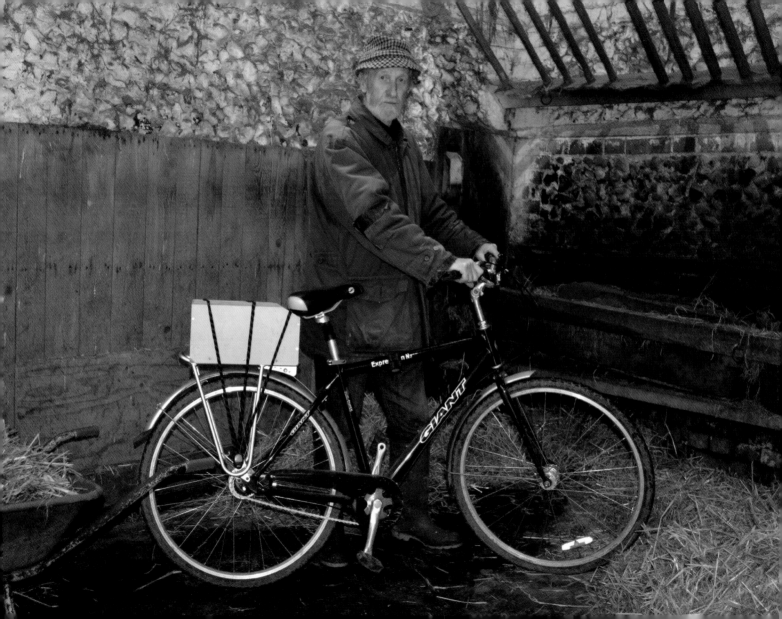

# Martin Calloman "Cally" Artist
*Bike approx. 1886, Eagle Manufacturing Works, USA*

Penny Farthings were only around for a relatively short period of about 30-40 years. The Eagle company made the 'back-to-front' Penny Farthing in order to try to avoid the rider being catapulted over the top of the large wheel, by having a small front wheel. But, within a very short time, the Safety Bicycle was being designed, with a chain drive and two wheels of the same size. This made it safe to mount and dismount from the bike. This would become known as the 'diamond frame' in reference to its lozenge design. Cally's cycling career started when he had a paper round in his teens. He also rode to school, like so many other boys. In those days, he says, "My bicycle was my enemy and friend. If I had a puncture it was glorious! It meant that I then had a day off school. If it rained, I hated it!" Eventually, he got himself motorised transport, and thought he'd left his cycling days behind.

However, in his mid-thirties, he was working in London, and often had to criss-cross the city. He came across a bike shop, and suddenly realised that he could get across town much faster on a bike than just about anything else. Gradually he collected various bikes from different sources; the internet, friends who gave him machines, auctions etc. He reconditions them, enjoying the engineering and design of each. He has ridden all over the country, literally from Land's End to John o' Groats. A true artist and raconteur, he gives lectures on the subject and loves to discuss all aspects of cycling.

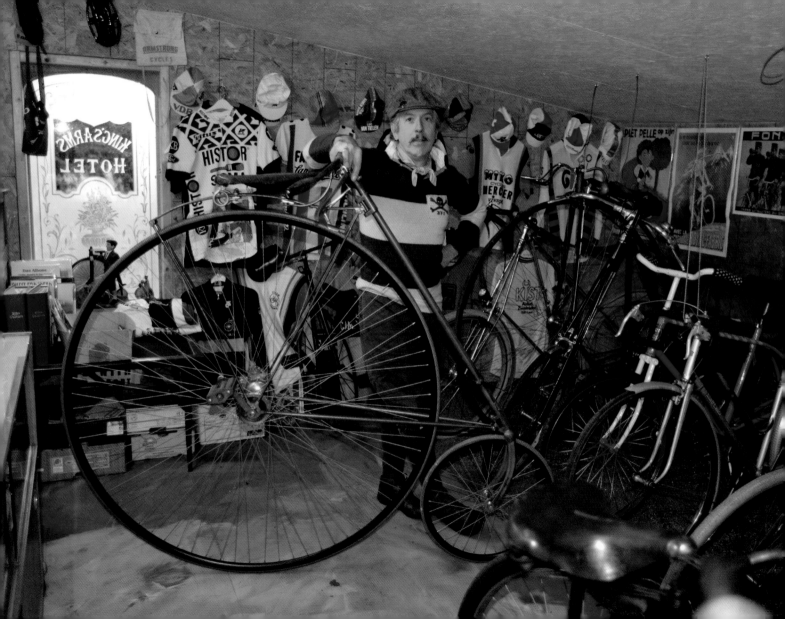

## **Phil Sanderson** Lawyer
*Fixie by Genesis (with Reynolds steel frame)*

At the moment Phil has three bikes; a titanium bike made by Linski in the USA, his Fixie by Genesis, and a Condor winter bike. He feels that carbon fibre frames don't give as much as titanium when going round corners, so he's never been tempted by them. He began his riding career by learning to cycle around an RAF base, as his father was in the Air Force. In his twenties, he tried several other sports, but eventually came back to cycling. His job is quite stressful so the ability to get out and explore the countryside is precious to him. Over recent years he and his cycling buddies have 'done' the Alps and the Pyrennes, but soon they will be tackling the UK. He originally comes from farming stock in Lancashire, so he's always been used to being out and about. Cycling is the ultimate freedom for him as it allows him to leave his everyday life and just be in the moment.

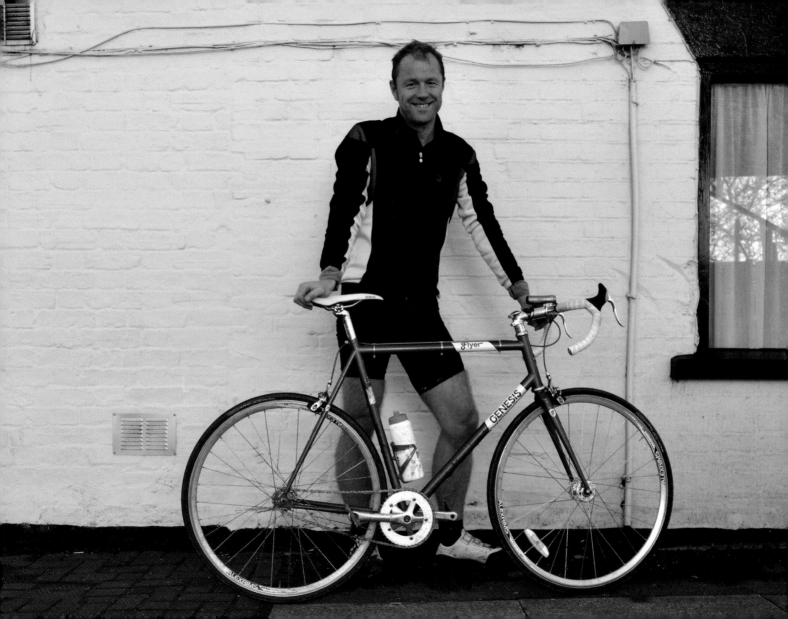

## **Leo Cinicolo** Photographer
*Look KJ 166, Campagnolo cranks, Cinelli headstock*

Leo's bike was one of the first carbon fibre frames to use aluminium lugs. This system didn't last very long, as a better method was found for joining carbon fibre tube together. Leo converted the bike to single speed. He thinks the bike is from the early 1990s, probably 1991. He learnt to ride as a small boy, and owned several track bikes as he grew up. Eventually, while at Cambridge School of Art, he really fell in love with cycling. It was the quickest and easiest method of getting around a flat city. He bought a racer from Gumtree and became fascinated by racing bikes. Almost immediately, his friends also got the cycling bug, and more bikes followed.

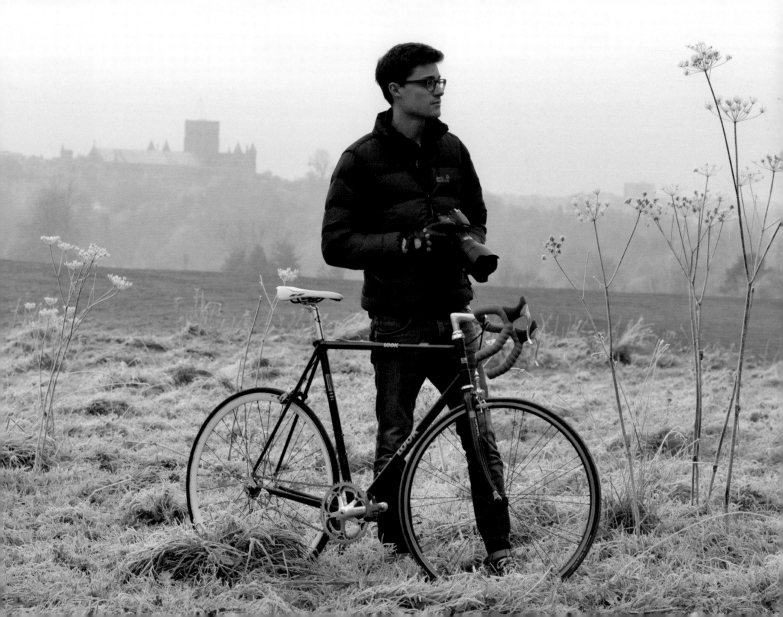

## Graham Parkins Building Services
*Moulton Midi bike*

Graham was working on a refurbishment job at a large house in Luton, when the lady of the house asked the men to clear the garage of rubbish. Hanging on the wall were two bikes: one was some sort of battered old racing cycle and the other was the Moulton Midi. One of Graham's colleagues chose the racer while Graham wanted the Moulton. He loves old machines, and used to have bikes and a few classic cars when he was younger. When he downsized into a smaller house, some of his collection had to go, so the Moulton, being small, suits Graham well. He says "I bought a new bike for my daughter, and quite honestly, the build quality is poor. Unless, of course, you spend thousands. But the Moulton is well-built. I think it's about 1965 vintage, and there's nothing wrong with it, even after half a century!"

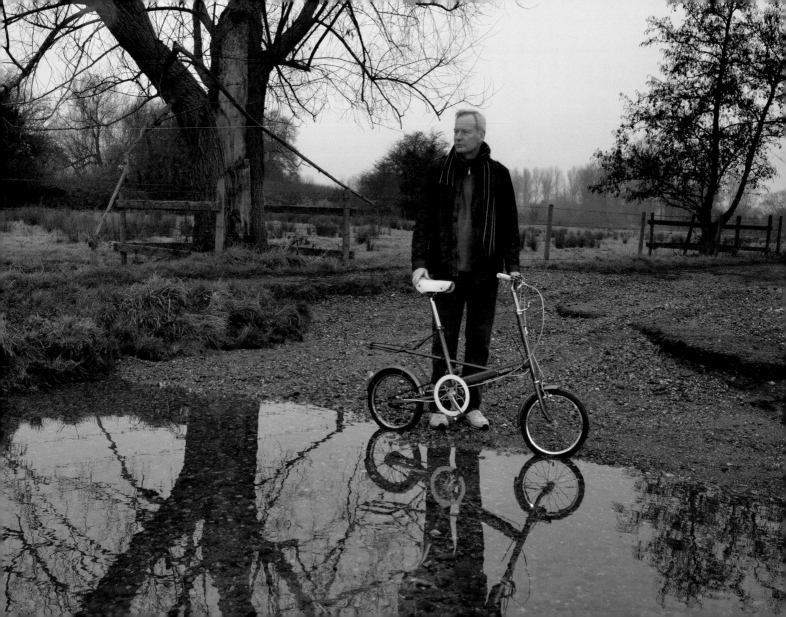

## **Ashley Best** IT consultant
*Wilier Triestina road bike*

Ashley is very fond of his Italian bike. After a lot of research he bought the machine based on its simple design and Italian good looks. The bike is a single speed, but not a fixed wheel, which suits the city rides Ashley does while commuting to work and exploring the town. The bike has transformed his life – he can get around easily in order to visit friends; he never has to worry about waiting for buses or parking; he feels much fitter than ever before and has total freedom to roam anywhere. He particularly loves exploring London in the early morning, before other people are up and about.

96

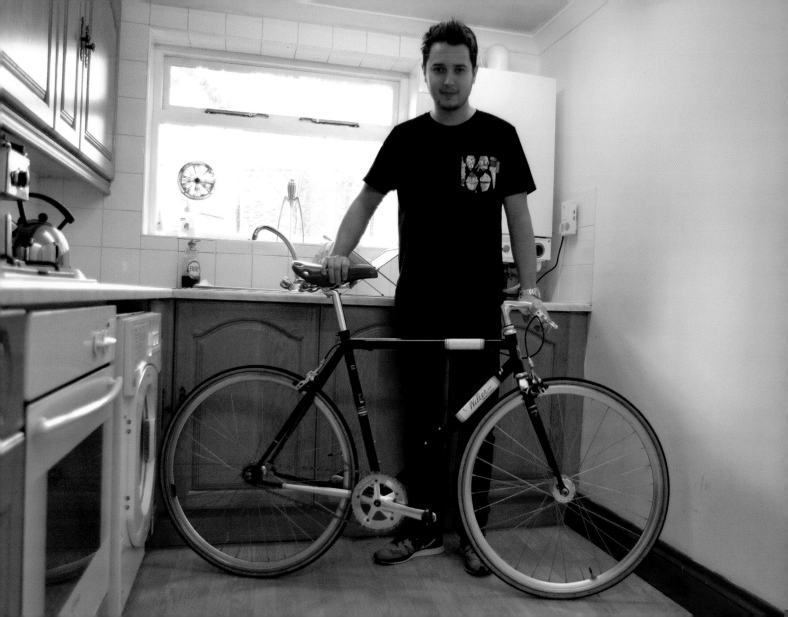

## **Mark Jones** Pawnbroker
*Shorter Rochford, Calida*

This bicycle was brought into Mark's shop by a customer who had bought it on a whim. "The chap had hurt his knee, he was a runner, and bought the bike, which was made especially for him. But his knee improved and he never used it. So when he brought it in I fell in love with it and bought it." According to Mark, his customer used the money he got for the bike to buy some cufflinks!

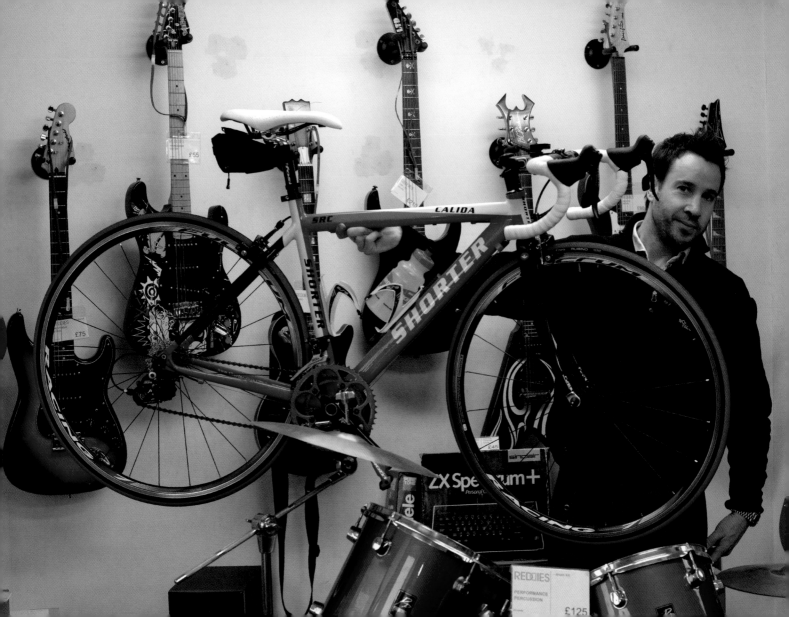

## **Roy Scammell** Stuntman/Actor
*Viscount Ladies racing cycle (with modifications)*

Roy has been many things in his life: professional skater, actor, acrobat and stuntman among others. He worked with some great directors, including Stanley Kubrick, Norman Jewison, Hugh Hudson and Ridley Scott. He also shared the silver screen with such legends as Marlon Brando, John Wayne, Roger Moore and Sean Connery. He recalls one bike stunt: "It was a film called *O Lucky Man* with Malcolm McDowell, I believe. I worked with him in *A Clockwork Orange* too. Lovely guy. Anyway, I had to crash while riding a bicycle into the side of a car. That was tricky, and painful. You are well protected inside a car, but on a bike, you are very exposed. Anyway, we did the gag and got the shot."

Roy's present bike is a bit of a 'hack' variously modified by him to suit his needs. He goes out every day cycling round the lanes in order to keep fit. He never locks the bike up, and it never gets much attention so no-one wants to steal it. He has three bikes in all, and the present one has been in his possession for over 10 years. Just after the war, he belonged to the Bath Road Racing Club, where he was a serious racer. The members would often head down to the sea at Brighton. Roy's first bike was given to him by a friend. He thinks it had a two-speed fixed wheel and it might have been called a 'Saxon'.

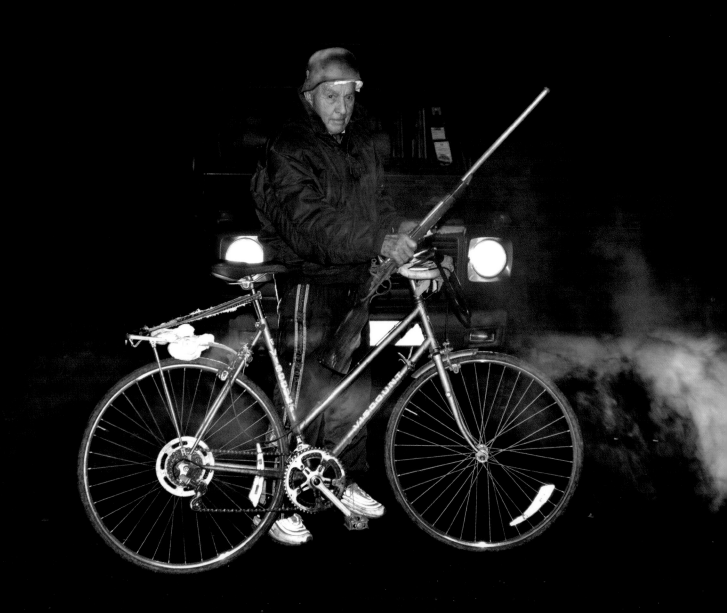

# Rosie
*Christiania 3-wheeled bicycle*

The bike is made in Denmark where these kinds of machines were made to fulfil a variety of purposes, of which child-transportation is Rosie's preferred option. The machine was purchased via a London importer. She has always enjoyed cycling, but it became somewhat more essential while at university in Edinburgh, and later commuting in London. This machine is very useful for taking the young boys out and about: they have a wonderful forward-facing view of the world, although going up even slight inclines is hard work!

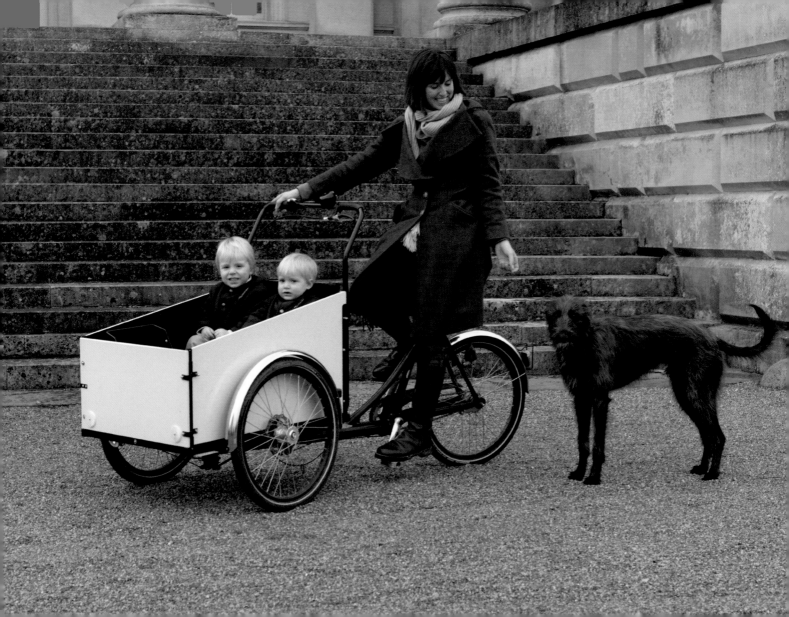

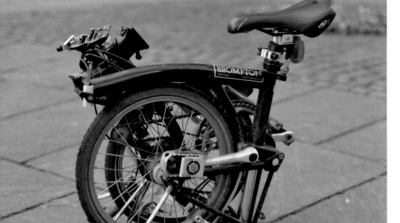

# George Woods Barrister
*Brompton folding bike*

George's godfather designed and built the very first Brompton bike. He had been frustrated at the poor design and usability of the folding bikes which were available at the time and decided to make his own. He was living opposite the Brompton Oratory and borrowed the name for his machine. When George was about 18 he did some work at the Brompton factory and, instead of wages, he was given his Brompton bike, which he still uses daily to get to work. As a boy, he was encouraged to cycle by his father who felt that whatever the weather was doing it was immaterial to getting out and about. Nowadays, George and his father often pitch into the family's old Auster plane with a pair of Bromptons on board, and fly down to the Isle of Wight in order to spend the days cycling.

104

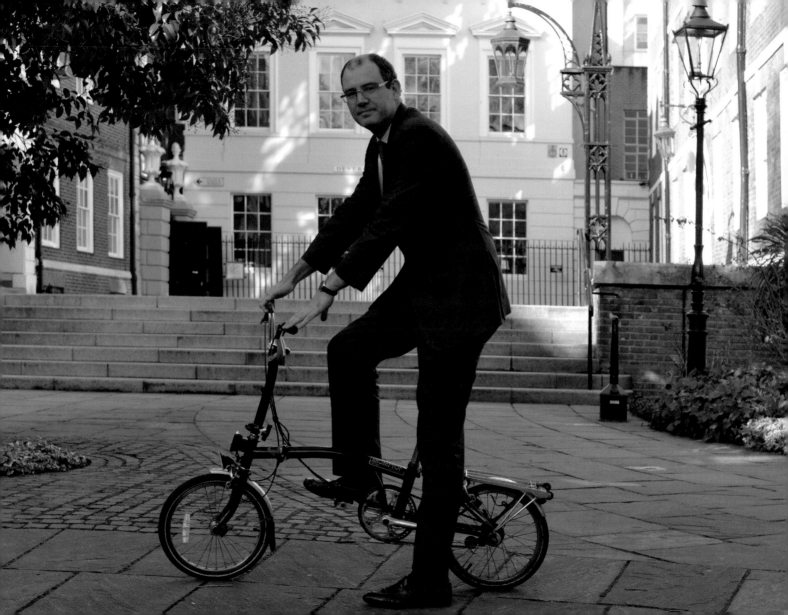

# Alex Kelly Adventurer
*The Thorn, a hand-built bike from Bridgewater, Somerset*

Alex went to the factory in order to talk to the makers, who took down the requirements and specifications for this customised bike. He spent a wonderful day there talking bikes. The reason for the visit was that, following a trans-European ride with his best friend Ed, he needed a tougher, more rugged bike with which to undertake a Middle-Eastern ride. The European tour had been more about speed and getting to a destination, but Alex had decided that he wanted to do a slower, more considered ride in the Middle East so that he would have more time to speak to people and see things. "You are very exposed when on a bike. A bike shows by its very presence that you have nothing to hide, so people tend to trust you. It's a great way to meet people. We had a big, tough bike, so we knew we could go anywhere."

He started off in Iran, in the south, and began the epic journey. There was no particular plan or route, so he cycled vaguely northwards, and west towards North Africa. The trip was sometimes dangerous, even before he reached Iraq. He made friends with many local people as well as soldiers. Going through Lebanon, he became a minor celebrity, appearing on TV. While riding through the Syrian desert he was knocked down by a lorry and was left unconscious. But, due to the generosity and kindness of local people, he was taken to hospital and received wonderful treatment. Having made a full recovery he eventually made it safely back to the UK.

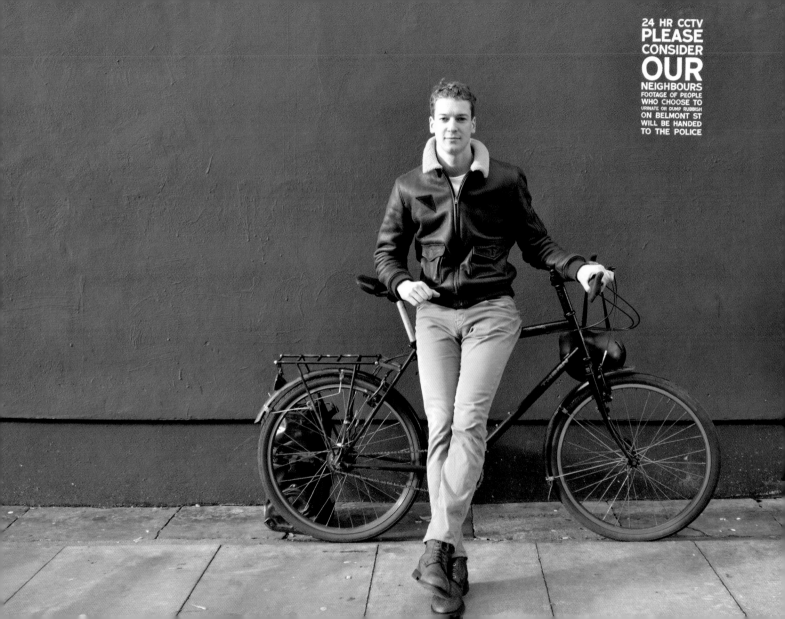

## Nicholas Saxby Land Rover mechanic
*BSA Winged Wheel and a Chopper*

Nick found the BSA on the farm where he now lives. He doesn't know where it came from but he felt sorry for it and gave it a home in his garage, where it has hung for the past ten years. The Chopper was found abandoned in a skip. He fished it out and used it until he outgrew it and, as he is reluctant to throw things away, it has been hanging in his workshop ever since.

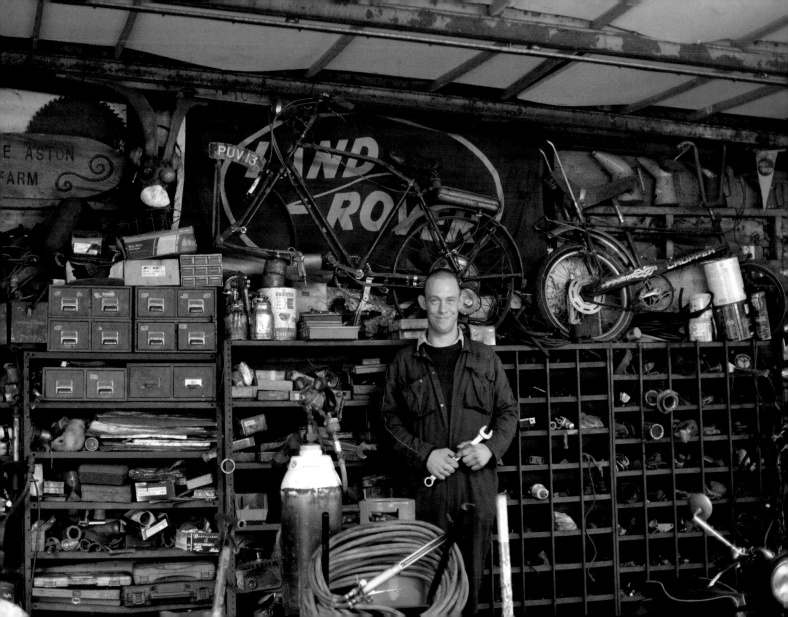

# **Elizabeth Harris** Cheesemaker
*Peugeot road and track bike*

Elizabeth's husband David was always a keen cyclist, so it was inevitable that she would also get a bike. When the children were young, the family used to go out for rides and picnics. However, since David was so competitive, he wanted to go out with his mates on longer adventures, so the family outings were left behind over time.

Elizabeth was one of four siblings and everyone had bikes in those days. Having finished university, she found a job at Rothamsted Research and regularly cycled 8-10 miles a day. When the goat farm became established there was less time left for cycling, but the bike is still the best way to get around the farm.

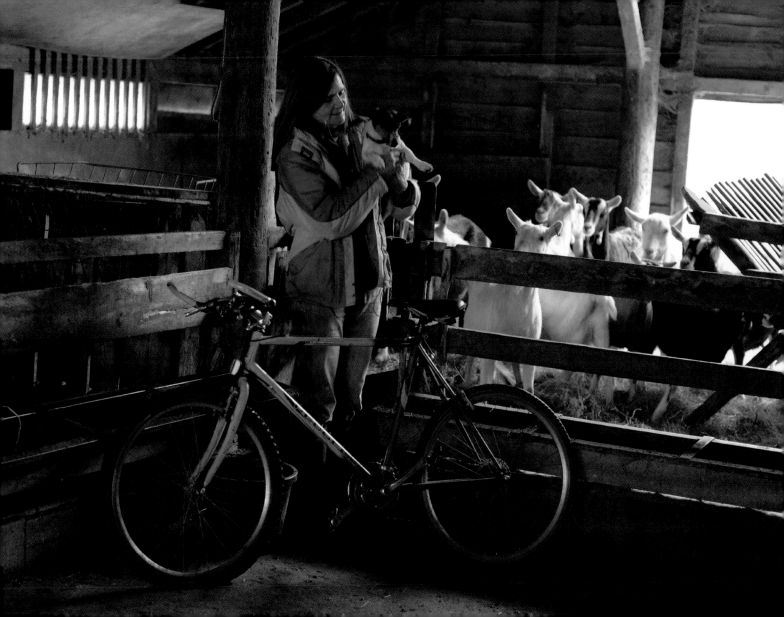

## **Paul Sebborn** Web Developer
*Dawes Super Galaxy*

Paul bought the frame second-hand from a bike shop and gradually added his own choice of 'bits'. He bought the frame because 'it looked nice – a proper bike'. After riding the bike for a couple of years, he upgraded the parts to a better quality make: "I am a big fan of a classic look for a bike, British-made, steel tube etc."

The first wheeled vehicle Paul ever had was a Mickey Mouse tricycle with which he disgraced himself by riding through a freshly-concreted driveway. (The tracks are still there!) As teenagers, all of his friends were getting trials bikes but, as he couldn't afford such a bike, he got himself a BMX. Together with a small group of friends he used to ride every waking moment. Even when he learnt to drive, the bike was piled into the back and he would set off for biking adventures. He recently did a charity ride, on a fixed gear bike, of 100 miles, at night, in temperatures of minus 3 Celsius!

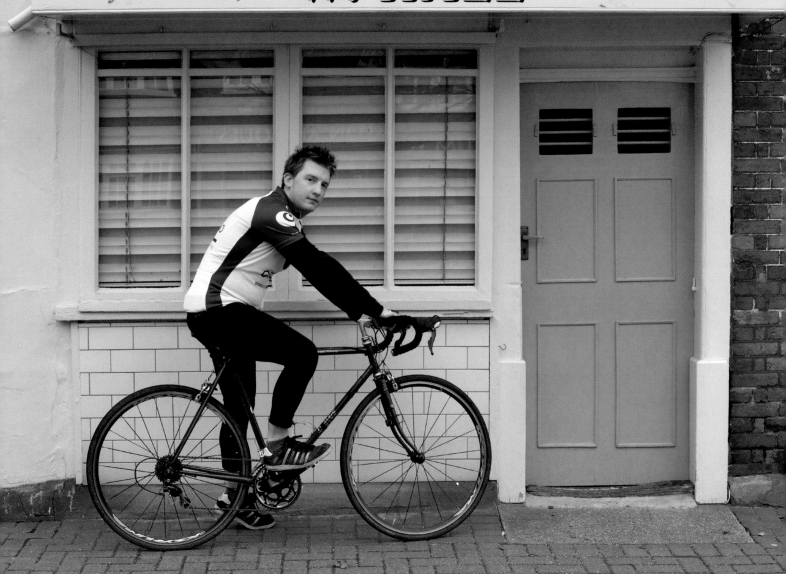

# **Andrew Scholes** Writer
*Old tricycle*

Andrew worked in the aircraft industry for most of his life. When he retired he took up the pen and has written several short stories. He says that he first rode a bike when "in short trousers" but has rarely ridden since although, because of his background, he does appreciate well-designed machines. His son-in-law is a real bike enthusiast so Andrew keeps those bikes in his shed.

Andrew's wife spotted this old tricycle in an antique shop and fell in love with it. When she asked if it was for sale the owner suggested a price of £20 and the deal was done. Ever since, the trike has been parked by the corner of Andrew's house. Every Christmas it is decorated accordingly. During spring and summer months various flowerpots hang on the frame, drawing admiring glances from passing motorists and families. "My wife and I are very fond of the old trike. It's like an old friend."

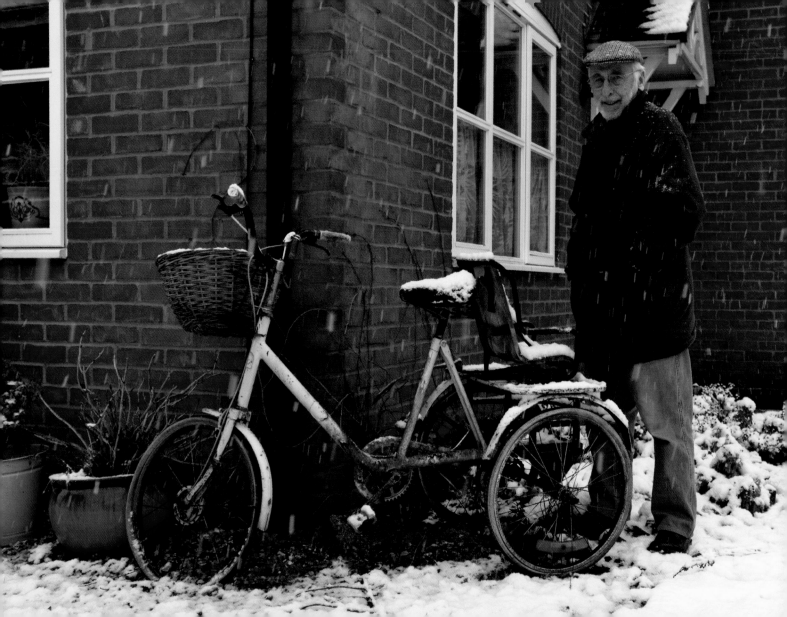

# **James Atkins** Web developer
*Look bicycle*

James' bike is very light – under 20 lbs. He wanted something for road racing and chose this machine because the bike is very fast and he is rather competitive. He used to ride trials bikes when he was younger and gradually realised he was hooked on cycling. A few years ago he was part of a display team. They used to visit various sites, schools and other venues in the area, taking their own kit, constructed from scaffold poles and plywood. Nowadays he can't imagine life without a bike.

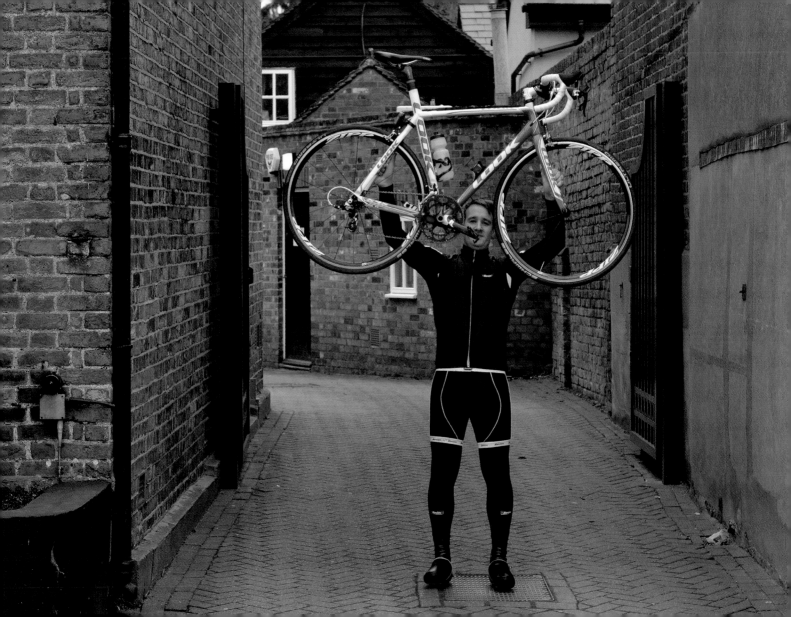

# **Dean Medrano** Actor
*Old Post Office bike*

Dean fell in love with this old machine when he first saw it inside the wigwam. He made an offer to buy it straight away. He loves the sturdy frame, the rod-operated brakes, and the 'proper' look of a traditional bike.

When he travels, the first thing he does on arrival in a new city is to rent a bike. He says it's the best way to explore a town. The joy of riding is that it slows down time and gives you the feeling of being part of the people and places.

When he was about 16 (and living in the United States) he had a high-specification racing bike, for which he paid $500, a lot of money back then. He was a member of a cycling club, but also rode alone on long trips, often taking weekend rides. Dean recently got married and luckily his wife shares his cycling passion.

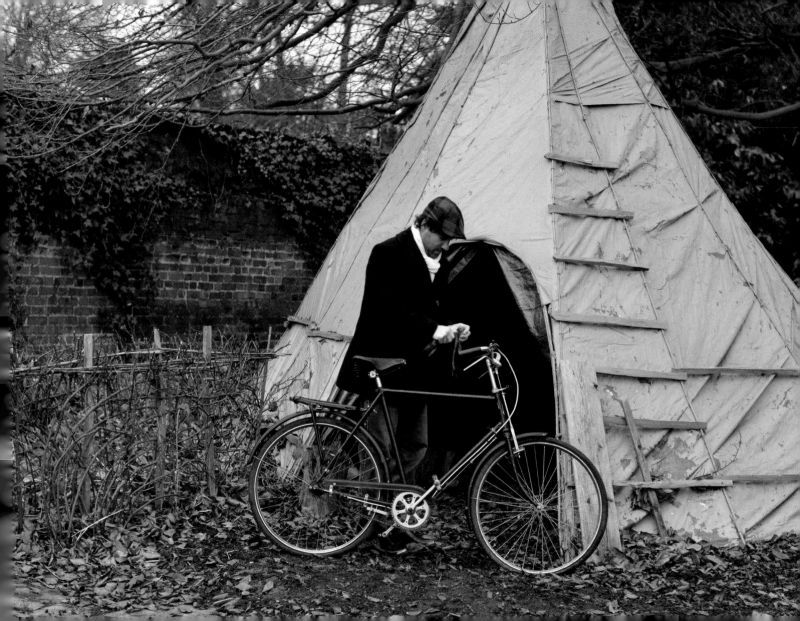

# Graeme Freestone King Frame builder
*Graeme's own unique frame*

Graeme has spent most of his working life as a bicycle mechanic.
Having learnt to build wheels, his next challenge was to learn how
to build frames. He thus became interested in the artiginal building
of frames rather than industrial methods. His first frame was TIG
welded and made of steel. It took him four days to build and, he
recalls "it rode like a brick!" He still has it and occasionally rides it in
order to be reminded of all the things that he did wrong. He raced at
Elite level for two years in France. Subsequently he has ridden quite
extensively in the UK, mainly racing on the road and in time trials.
His wife Ruth has been ranked in the top ten of female time trails in
the UK. He met her in a bicycle shop, curiously enough! That was
twenty years ago.

120

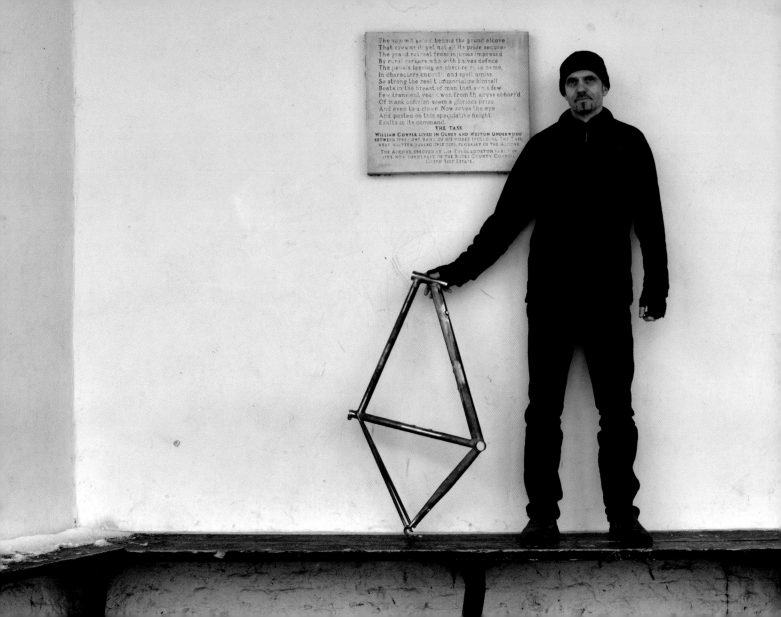

The summit gain'd, behold the proud alcove
That crowns it! yet not all its pride secures
The grand retreat from injuries impress'd
By rural carvers who with knives deface
The panels, leaving an obscure rude name,
In characters uncouth, and spelt amiss.
So strong the zeal t'immortalize himself
Beats in the breast of man that ev'n a few,
Few transient years, won from th' abyss abhorr'd
Of blank oblivion, seem a glorious prize,
And even to a clown. Now roves the eye,
And posted on this speculative height,
Exults in its command.

**THE TASK**

WILLIAM COWPER LIVED IN OLNEY AND WESTON UNDERWOOD
BETWEEN 1767–1795. MANY OF HIS WORKS INCLUDING THE TASK,
WERE WRITTEN DURING THIS TIME, PROBABLY IN THE ALCOVE.

THE ALCOVE, ERECTED BY THE THROCKMORTON FAMILY IN
1753, NOW FORMS PART OF THE BUCKS COUNTY COUNCIL
GREEN BELT ESTATE.

## Adam Enthusiast for all things mechanical
*Pedersen bike, made in Denmark*

Adam's bike is less than 10 years old, although Pedersen's design goes back to the late 1890s. Originally the machines were made using thin-walled tube and were the lightest bikes on the market. They were highly successful in racing and, in the early 1900s, they were regarded as the Rolls-Royce of bicycles. This bike is unusually comfortable to ride because, essentially, it has a fully-suspended seat. The ride, even now, is very smooth, making it a classic commuting bike.

Mikael Pedersen, the bike's inventor, was a forward-thinking pioneer. He came to England and began making his bicycles in Dursley in Gloucestershire. The bikes had hub gears even then. Adam loves these bikes so much he has commissioned another Pedersen design to be made specially for him in Germany. That bike will have a woven string saddle and disc brakes and should weigh about 19lbs. He has cycled since he was young and has never really been without a bike. His list of bikes includes recumbent, touring, Moulton, Pedersen, folding designs and more. A few years ago he went on a frame-building course in Wales with his son Joe. Subsequently they made the frames into finished bikes which are still in regular use.

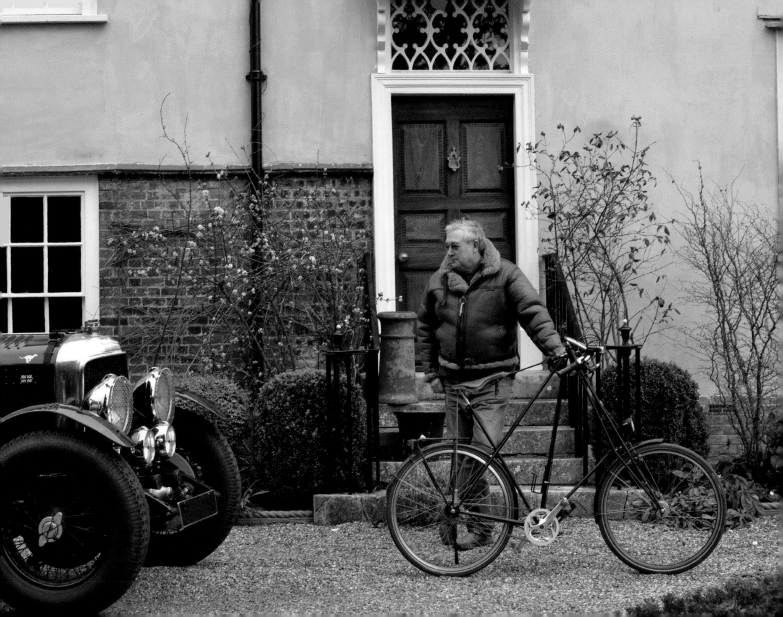

## Noel Hurley Businessman and triathlon competitor
*Alan Mercurial cyclo-cross bike*

Noel uses this hand-made Italian bike which was specifically made for the cyclo-cross field, although he has other bikes too. In addition, he is currently restoring a bike using a traditional tube and lug frame as the basis.

Like many children, his first bike was a basic Raleigh with which he used to go to school and ride out with his friends. His interest waned as a young man but was reawakened later in life when a close friend suggested they do triathlons together. As he is quite competitive, the idea took hold. This was, of course, cycling for racing and for keeping fit, which is increasingly important as one gets older. He loves being able to lose himself in the open air, and the friendship with cycling buddies.

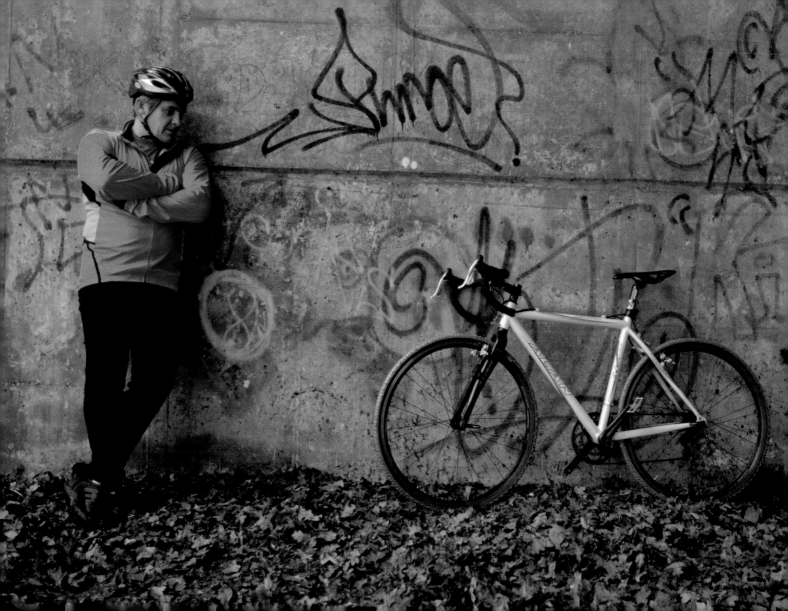

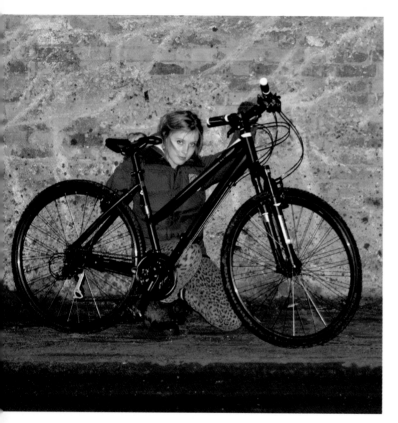

## Cleo Newton Student
*SR Suntour Cube bike*

Cleo insists on her full name – Elsa Jane Clementina Newton – although most people call her Cleo. Her current bike used to belong to her father, and when he no longer needed it he passed it down to her. She uses it almost every day; for visiting friends, for school, for trips to other villages and so on. She loves cycling, but many of her sixth form girl friends don't share her passion for two wheels. So most of her cycling buddies happen to be boys. She feels that it's safer not to be out and about on her own, especially during dark evenings. Cleo doesn't aspire to own any particular make of bike, just one which works and is strong enough to be used hard. "Off-roading is my favourite," adds Cleo, "and I do treat my bikes roughly. I'm not gentle with them. Going down steep tracks or over rough surfaces at speed is really exhilarating. I need to escape from the dull and boring."

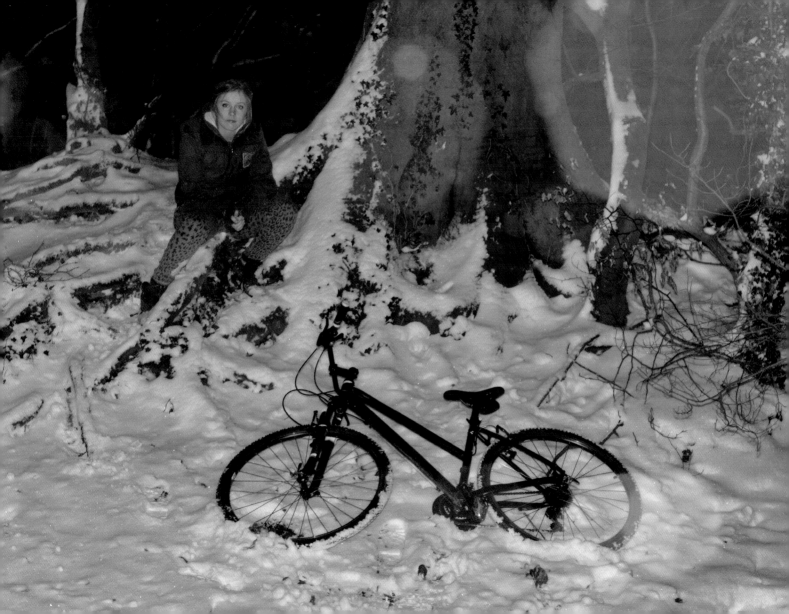

## Derek Cross Former aeronautical engineer
*E. G. Bates low profile racer*

Derek bought this bike in part exchange from a customer about 20 years ago (when he had a cycle shop ). As soon as the customer brought the machine into the shop Derek knew exactly what it was; he recognised the bike and the particular 'Moscow' handlebars. He reckons that there might be five such bikes ever made. "All I do is keep it nice. I don't do much else to it, apart from keeping it clean. Hopefully it will last 100 or 200 years!" says Derek. He rarely rides it, but enjoys the beauty of the machine, as if it were a priceless painting. As an engineer in the aircraft industry he appreciates the machine and its design. "After all, even the Wright Brothers were cyclists."

## **Simon Apps** Trials bike competitor
*Onza trials bike*

Simon made this bike out of various bits from other bikes which he used to own. The machine is always evolving as new, better components come on to the market. His father introduced him to cycling at an early age, and he has continued to ride ever since. On one spectacular ride, his dad took him from John o' Groats to Land's End. He has worked in various bike shops over the years and he enjoys it greatly, as he gets to meet other interested amateurs and professionals and works with bikes all day. He has acquired several bikes along the way: a road bike, mountain bike, this trials bike and a BMX.

## **Reg Ellis** Retired
*Raleigh ladies touring bike*

Reg worked in the Brooke Bond tea factory in Redbourn for 50 years. He has been retired for a good few years since then, but still maintains an interest in bikes. He first got the cycling bug in 1946, and bought himself a Raleigh with which to cycle to work from Brentford to Aldgate, London. After a couple of years with the Raleigh, he was eventually able to buy himself a Claud Butler frame, which cost a week's wages. He made up the bike using various other components. His Butler frame was quite special in that it had, on the frame, the five Olympic rings.

Reg met his wife Audrey (to whom he has been married for some 60 years) on the beach at Eastbourne. In those days a lot of people used to go on cycling holidays, either with the Youth Hostels Association or the various Cycle Touring Clubs. It was a way of getting out into the countryside away from the busy cities and factories. Many relationships were formed in this way.

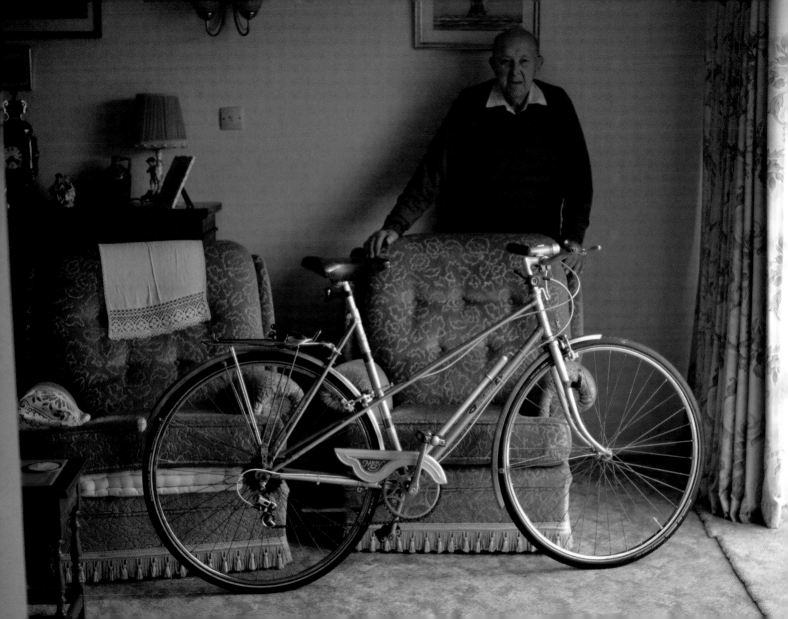

## **Alexander Loudon** Product designer
*Lapierre Spicy 3/6 Large bike*

Alex bought his bike from Evans Cycles three years ago. He had previously worked for the shop and it seemed natural to choose a bike from them. His cycling history began in his early teens. At the time he was allowed to go to the park every Sunday morning. His interest developed from there, and he got his first mountain bike, on which he cycled after school and at weekends. He then bought a road bike, and started to cycle even more regularly. When he went to university in the South-West, he had easy access to plenty of coastline and rough terrain, so the mountain bike got a lot of heavy use. Alex regularly cycles to work and back across London. Since bike designs change quite often, he doesn't have a single bike to which he aspires, but says he would like to own a carbon fibre model one day.

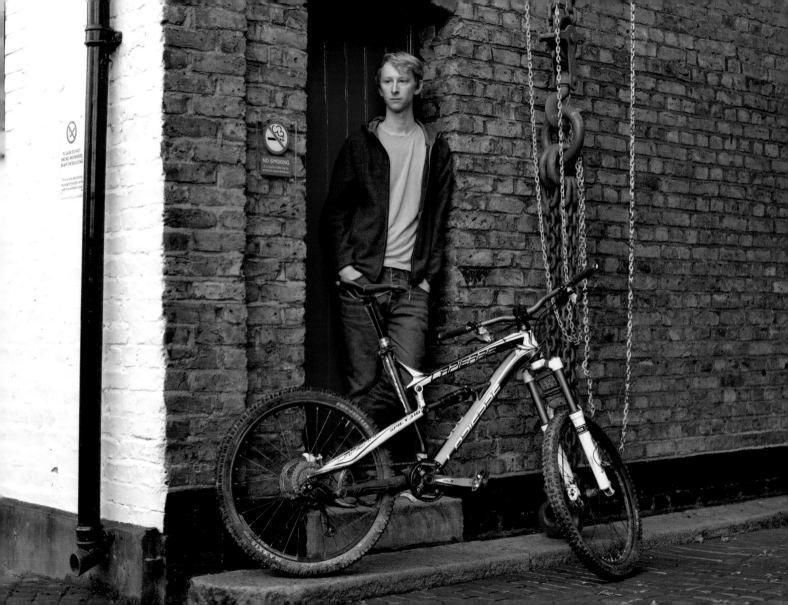

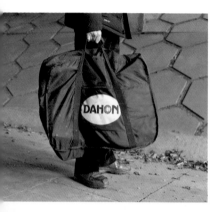
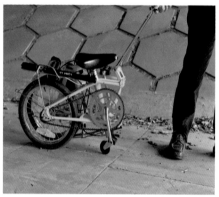

# Anthony Oliver
Computers
*Dahon folding bike, made in USA*

Anthony bought this bike when he went to the London Boat Show. He thought it might be useful on boat trips and camping holidays. When his family had a holiday on a narrowboat the machine came in handy for going to fetch provisions. Anyone could ride it and it was easy to stow. The bike has a small castor wheel which can be folded down and, by using the chrome handle it can be towed along the ground with the shopping on the carrier. In effect it transforms into a three-wheeled trolley. Although the bike doesn't get much use nowadays, Anthony hopes to pass it onto his grandchildren for them to use.

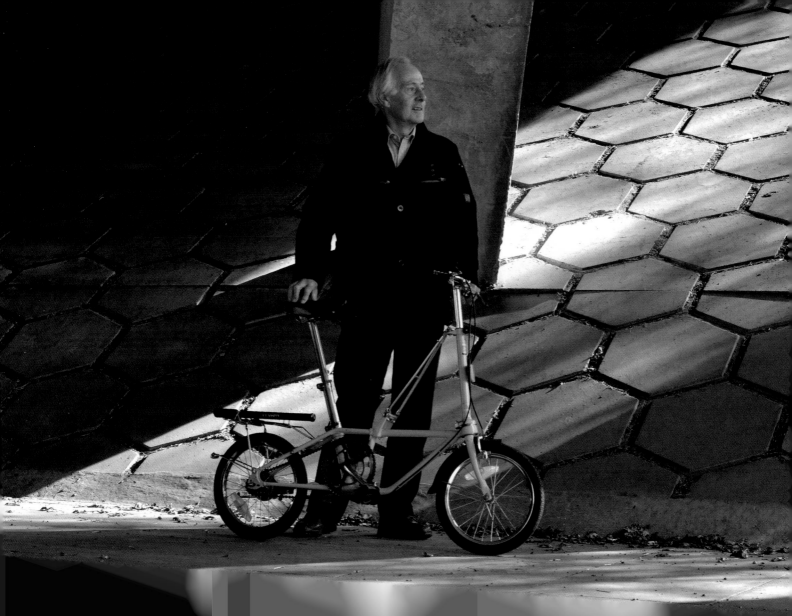

## **Brian Loudon** Architect
*Charge Plug, single speed city bike*

Brian considers himself a "fair weather city cyclist". He has had many bikes over the years, but found that he wanted something which was more comfortable than previous machines and, being an architect, wanted something beautiful, sleek and well-designed. He has done the London-Brighton four or five times in the past, as well as other rides. Nowadays, he loves to go urban cycling on Sunday mornings, sometimes with company, sometimes on his own. It's a good time to enjoy looking at buildings; you can stop more or less anywhere, and he likes to end up having lunch or coffee by the river. Brian made up his first bike from bits scavenged from town rubbish dumps. There was a lot of competition among his school friends as to who could make the best 'scavenged' bike. It was a source of pride that it had to cost nothing. His interest waned for about 20 years after school, but came back once he moved to London and he now enjoys life on two wheels once again.

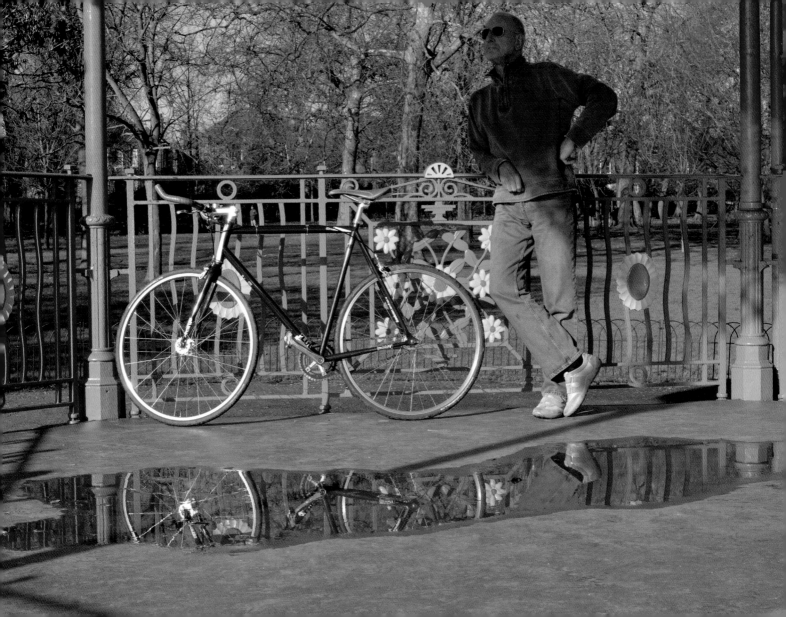

## Simon Hart Businessman and engineer
*Pinarello FP2 bike*

Simon's machine is partly made from hydro-formed aluminium and carbon fibre. This makes the bike extremely tough and resilient as well as light in weight. He uses it most weekends on club runs and outings. His first serious bike was a Jack Taylor, which he bought by saving pocket money, doing odd jobs such as washing cars and by not going on school trips. He particularly wanted a hand-built bike made in England close to where he grew up. He was 15 years old at that point. Throughout his life he has never been without a bike "I think I have about six or seven now. My son is just beginning to show a serious interest in bikes too. So, I guess it runs in families, this bike thing." Since Simon's job is quite demanding he goes out riding most weekends in order to get exercise and enjoy the open air and the company of other club mates.

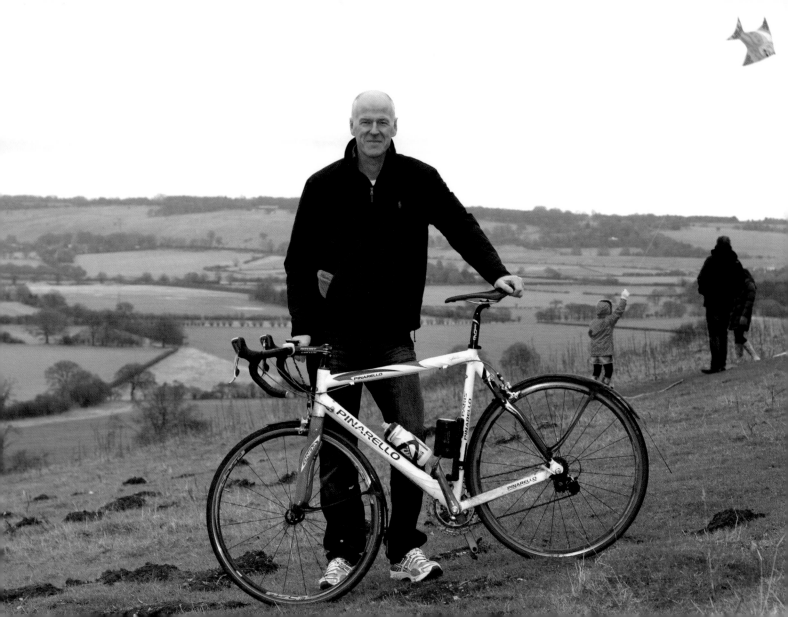

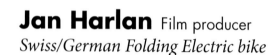

## Jan Harlan Film producer
*Swiss/German Folding Electric bike*

This electric bike can be bought in Switzerland or Germany; Jan bought his in Freiburg. It is an extremely solidly-built bike with a rechargeable battery. It's highly convenient, as it can be carried on a train or in the boot of a car. Jan's love of beautiful engineering encompasses not just bikes, but cameras, lenses, computers and so on – in fact anything which is well-designed and constructed from good materials. His has fond memories of his first bicycle, which was given to him by his aunt, in Germany. He remembers the make well: a 'Kirsch' that was pale green.

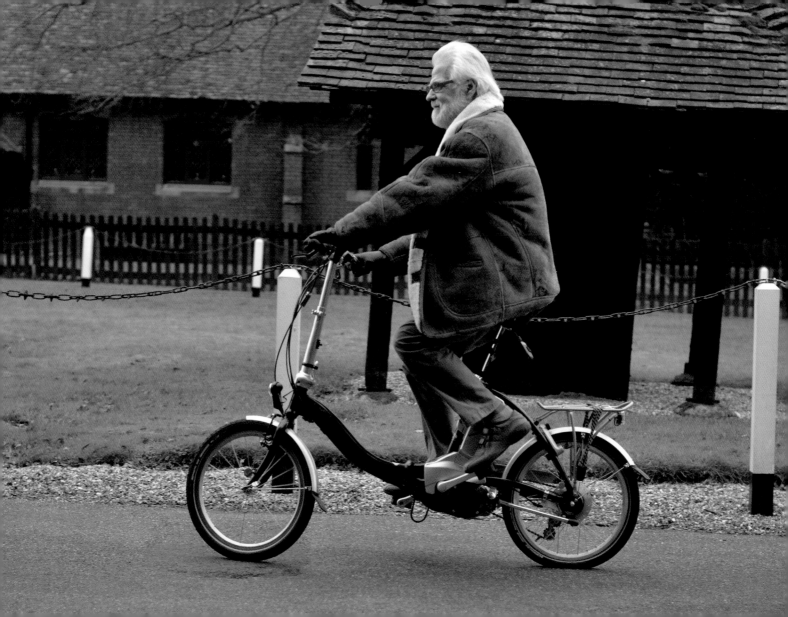

## **Duncan Twigg** Cycle Messenger
*Anonymous road bike*

Duncan has been a messenger for over two years. He began because he was short
of money and it was a job which just required a bike. He also enjoyed being outside
and keeping fit. When he arrived in London from his home town of Sheffield, he had
his A-Z constantly open, but he now knows the city well. Curiously, bad weather is
good for his business, as people don't want to walk about delivering packages in
the rain.

144

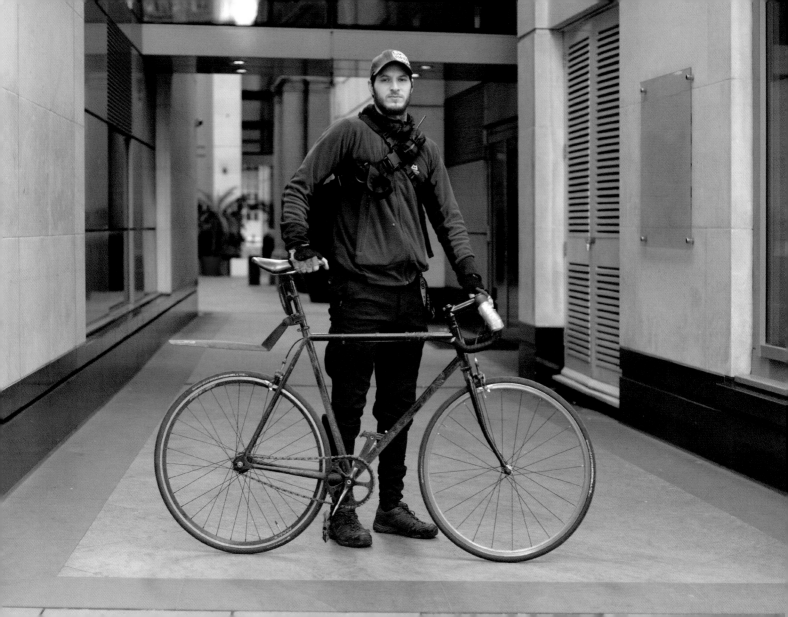

## **Tony Clayton** Economist
*London Barclays hire bike*

Tony uses bikes daily. He commutes to work regularly, owns a Dawes bike and a tandem, and uses hire bikes several times a day. On the day he was photographed it was his third hire bike of the day, and he was in a great hurry. He is a prime example of why a city needs a bike hire scheme. The machines of London's cycle sharing scheme are popularly known as 'Boris Bikes', after Boris Johnson who was Mayor of London when the scheme was launched. At its busiest, the scheme has accounted for nearly 50,000 journeys a day in the capital.

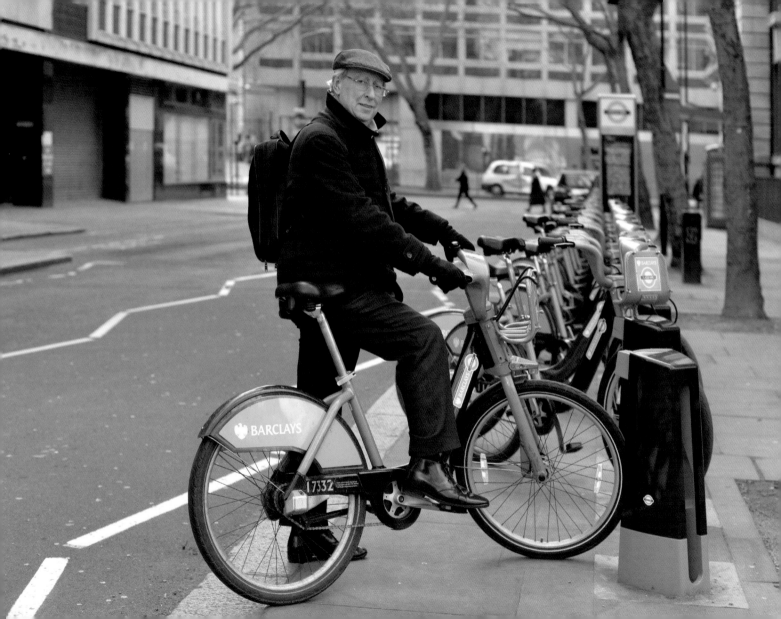

## **Stephen Norgate** Collector, restorer, frame builder
*Hetchins Fastback*

Stephen originally saw a similar bike when he went to visit a man (who we shall call Ted Smith) in the North-West. He says "Apparently, so I hear, this Ted Smith was known for faking Hetchins bikes." But Stephen bought a proper, original Hetchins from Smith, and came away thinking what a beautiful machine the Hetchins turned out to be. Later in life, Stephen was able to buy a "Hetchins" made by Smith which was exactly the same colour as the original one he'd bought years before. Even though the present bike is known to be a fake, he still loves it "Because it's a hell of a good looking bike!"

The other frames pictured are a Paris Ghelibier from the 1940s and a Ron Cooper from the 1970s. Stephen appreciates the skill of the lug-maker and the frame-maker in both these latter frames, as well as the unusual designs. He still owns his first bike, a Carlton Pro-am, but doesn't cycle as much as he'd like – he's too busy tracking down parts and frames!

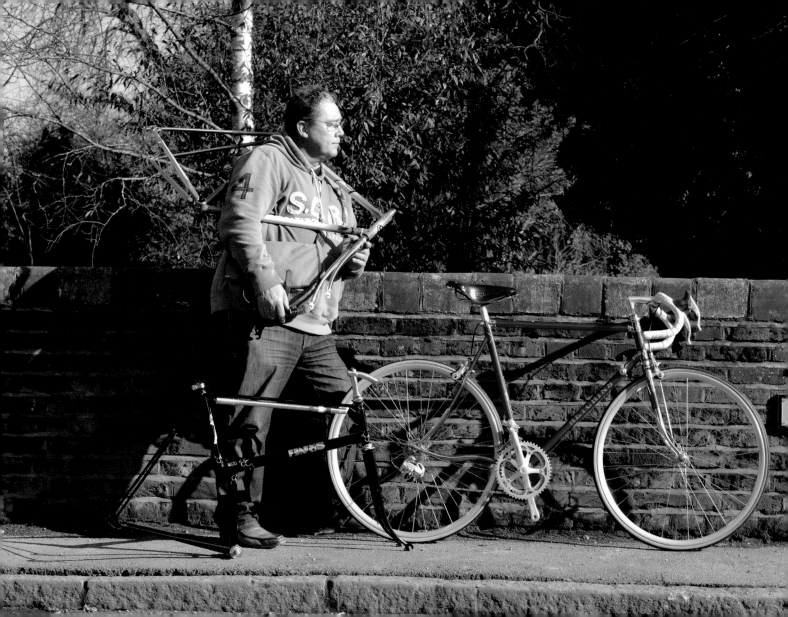

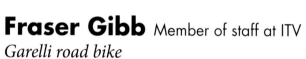

## Fraser Gibb Member of staff at ITV
*Garelli road bike*

Fraser is standing behind a crowd of people attending the world premiere (at the Odeon, Leicester Square, London) of *Run For Your Wife*. He uses his bicycle all the time and categorically says "I couldn't live without my bike".

## Graham Lane Member of staff at Porsche Centre, Hatfield
*Porsche FS Evolution*

The bike in the photo is made from 7020 aluminium and carbon fibre. It has suspension with individually adjustable springs and shock absorbers; hydraulic disc brakes; and 9-speed Shimano gears. This particular machine was left temporarily almost 10 years ago by a customer when buying a car, but somehow the bike is still being lovingly cared for by the Porsche Centre, awaiting collection.

Graham is regarded by his colleagues as a cycling fanatic. He has two bikes, a Specialized Rockhopper-Pro mountain bike and a Wilier Triestina, both of which he rides regularly to keep fit. He tries to ride at least two days a week and in the evenings during summer time. He has been riding most of his life, starting off with a Raleigh which he used to ride to school and with which he did his paper round. His father was a keen cyclist, which had an early influence on him.

154

# Anne Kuhne Lawyer
*Herkules road bike*

This bike was built in Copenhagen by Anne's friend Lars. The basic frame is a Tange with the additional parts being chosen by Anne. When she moved from Copenhagen to the UK, the bike came with all her other belongings. She has owned it for 22 years and it is her faithful companion; she uses it for shopping, for commuting to the station and for general road work. She also has two other bikes.

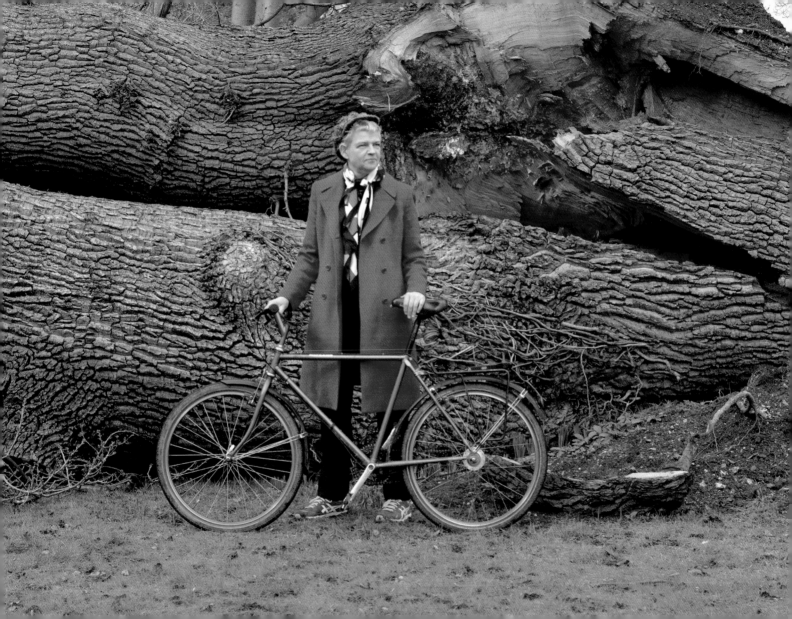

## Peter Bonfield Businessman
*Globeroll fixed wheel town bike*

Pete used to ride for Specialized, the bike manufacturer, who have a brand called Globe, which is a city bike. When the company introduced a fixed wheel version of the machine, they contacted him and gave him this bike. He has been cycling since the age of three, so it's in his blood. At one point he did become a national champion but he didn't make the Olympic Team. He rides every day when he gets the opportunity. He has several other bikes, but prefers the Globeroll for general use.

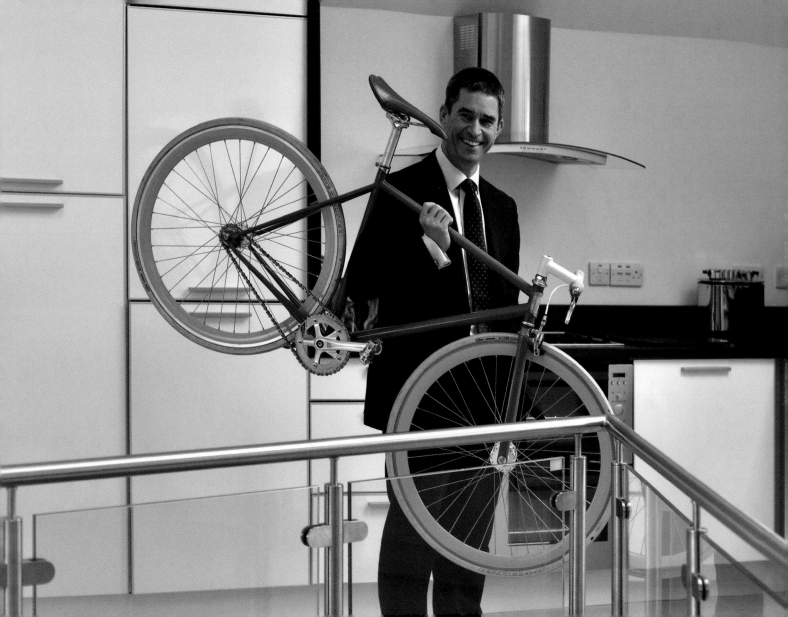

## Robert Seex Film props maker at Pinewood Studios
*Spooky Bandwagon*

Robert first saw the Spooky in a cycling magazine when he was younger and has always loved its rugged look. He bought it from a girl he knew. They were both in the same club together. As a teenager, he used it to ride everywhere. Lately he has been using it to get around the film studio site. It's the quickest and easiest way to get around Pinewood. At home he also uses a Merlin Mountain bike.

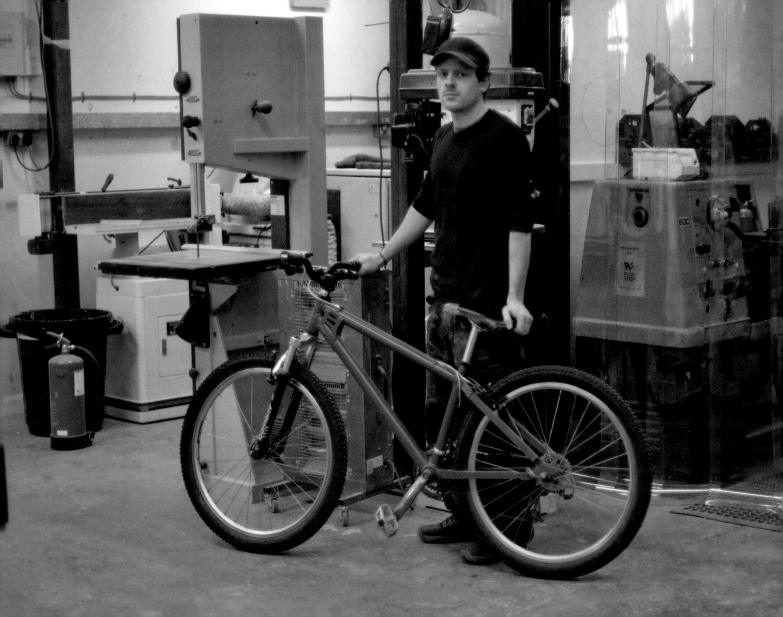

## Alex Cunningham Retired De Haviland Aeronautical Toolmaker
*Holdsworth racer*

Alex has had his Holdsworth for about 20 years. He tries to go out on it most days as he feels it's important to maintain a good level of fitness, and he enjoys getting out and about. He was apprenticed at De Haviland when he was 16 and cycled to work, like most people of his generation. He started out riding his uncle's bike when he was nine years old. The uncle was in the war and his bike was available. The machine was too big for the young Alex but he learnt to ride it by slipping one leg under the crossbar and riding with a slight "lean" to one side. It was hard work, as the bike was a fixed-wheel. Alex recalls "I couldn't stop it very easily, so I used to drive it into a neighbour's hedge. That brought it to a standstill!"

In 1947 Alex moved from Scotland to London and joined the Scouts. The Scoutmaster was a cycling enthusiast so encouraged his troop to ride bikes. Later in life, Alex did some racing and the Tour of Britain, but never took up serious racing due to family commitments. Nonetheless, the cycling bug has been with him since boyhood, and he can't imagine not being able to cycle.

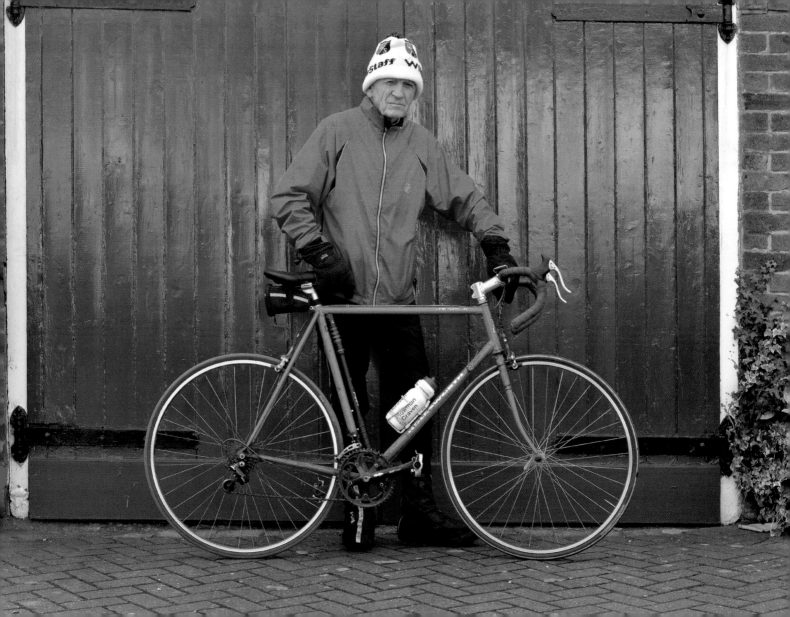

# **Bob Castle** Driver
*Raleigh road bike*

Bob got his bike (he thinks it's called a "Runaround") from Cornwall. About ten years ago, a friend of his sister was retiring, Bob went down to Cornwall to visit and got the bike while he was there. He loves old machines.

His whole family is interested in cycling, and go out on excursions as often as they can. Not wishing to leave their family pet spaniel Ruby behind, it seemed to be a good idea to find a way of taking the dog along. They solved the problem by putting Ruby in a rucksack which could be carried on Bob's back. The dog loves looking around from this great vantage point. Bob says "It's much safer for everyone. Ruby doesn't have much road sense!"

164

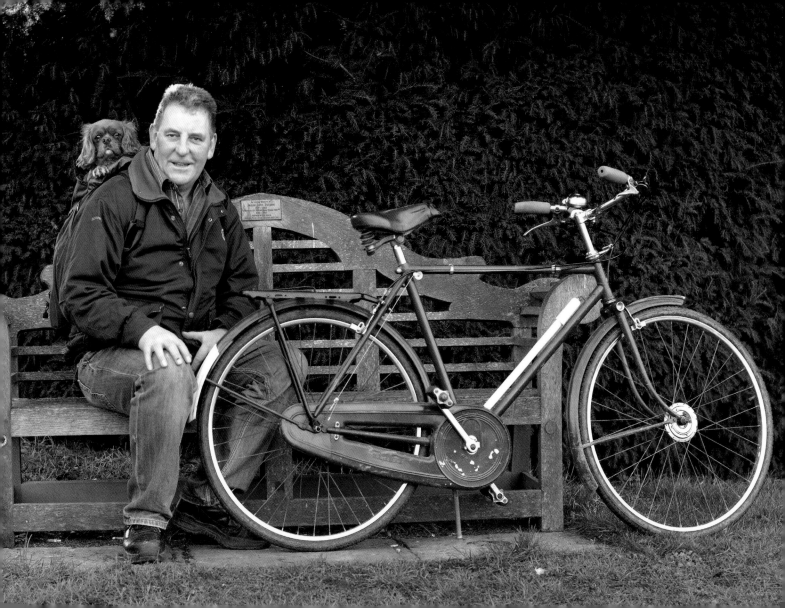

# Charlie Castle Schoolboy
*Elswick Hopper*

Charlie is very active and loves being outdoors. The church tower in the photo was the scene of one of his exploits: he abseiled down it to raise money for Christian Aid. In the process he made £130 in sponsorship for the charity. "It was a bit scary going over the top of the battlements," he says "but once I was going down it was alright. I love the old church because I wake up and see it every morning from my window."

The bike was one of a batch of about 50 bought by British Aerospace for use by visitors coming to see the Hatfield factory. When the place closed down, a lot of stuff was thrown out, including the Elswick which was rescued by Charlie's dad. The saddle still needs to be fixed properly.

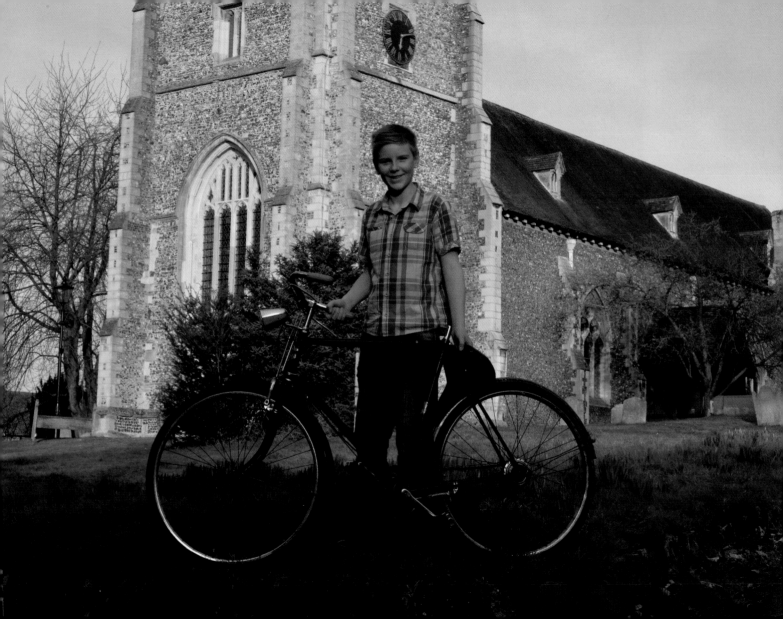

# Thomas Hallam

*Hetchins racer*

Thomas' father Terry bought the bike new in 1976. When he passed away, the machine was taken over by his son, who had the bike fully restored to its former glory. The finishing touch was the addition of the name "Terry Hallam" on the crossbar as a tribute to a great cyclist. The bike is a real 'looker' and gets a lot of attention when it's stationary. Thomas keeps it clean and polished and hopes that one day it will be passed down to another family member. He says "I am very lucky to be its current custodian. It's a thing of beauty, being able to own and ride such a beautiful machine."

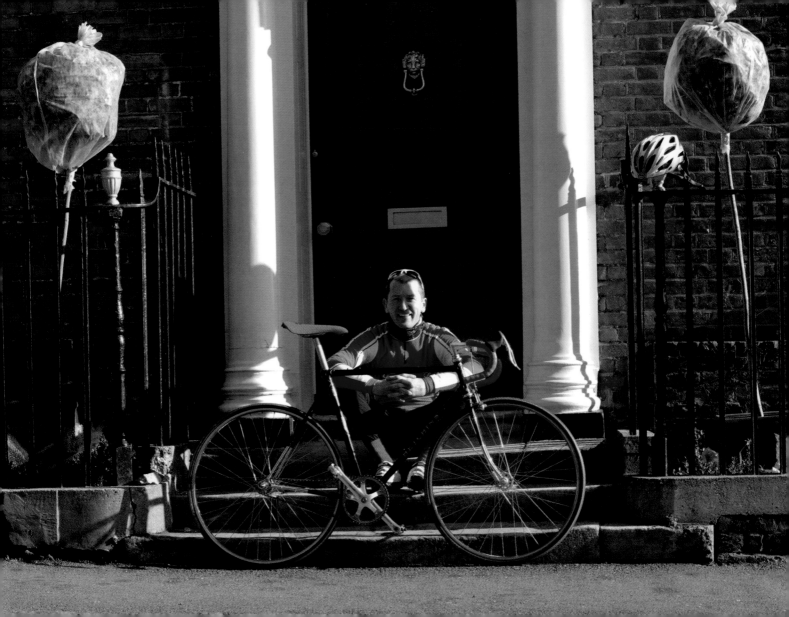

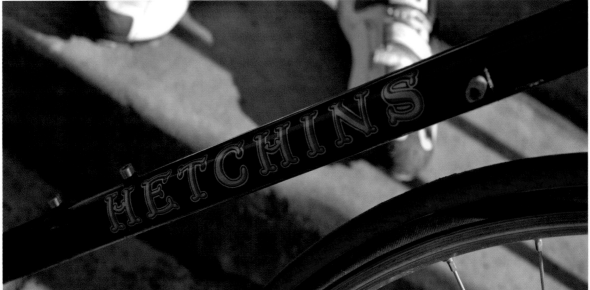

## **Andy Clarke** Verger at St Albans Cathedral
*Marlboro 12-speed racing bike*

Andy has had this bike for over 25 years. As the roads are so rough, he also uses a modern mountain bike. He took his Cycling Proficiency Test at eight years old, and is still proud of his score of 95%. He grew up on the Isle of Wight and used to cycle everywhere with his mates. His two sons both have bikes and he encourages them to cycle whenever possible. Andy says of his Marlboro "I love this bike. For long journeys on good roads it's wonderful – it just cruises!"

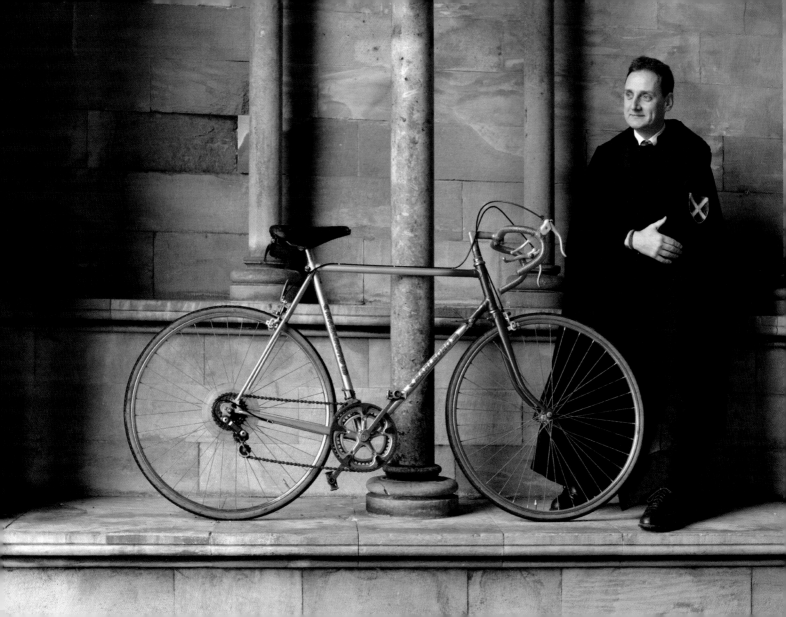

# Ricky Figg Bike builder and mechanic
*Specialized Rockhopper M4 SL*

Ricky got involved with bikes while he was at school. He did a lot of downhill riding and trials and found that he loved the sport and the atmosphere surrounding it. Because he used to ride a lot there were always repairs to be done, so he taught himself the necessary skills needed for customising and building bikes. He finds the manual work rewarding, and says there's nothing to beat the feeling of satisfaction when a customer collects his hand-built bike and says "Wow, that's amazing!".

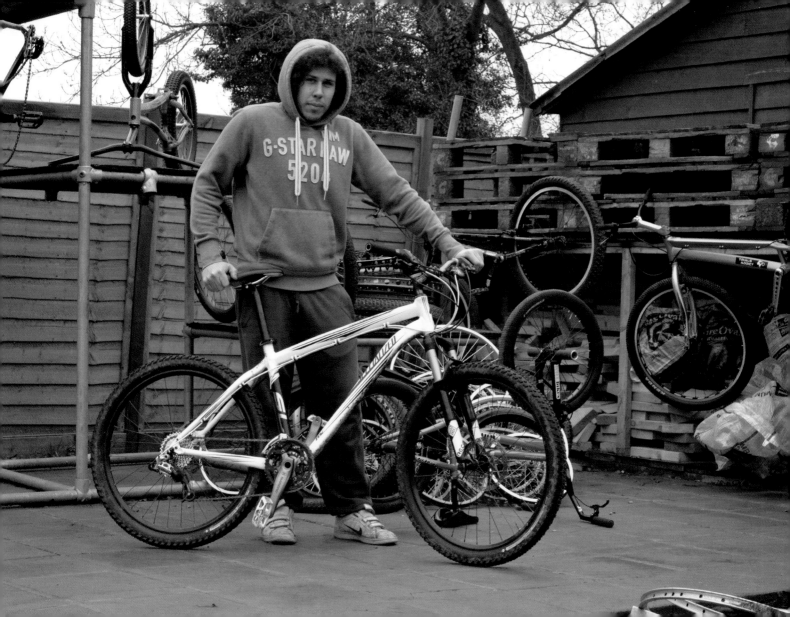

# Jeff Vetere
*Specialized fixed wheel bike*

Jeff hasn't been cycling for very long, a mere two years. He was working in central London and loved jogging to keep fit. Then he bought the bike and realised how convenient it was, so he used it for training, mainly in the parks; Regents Park, Hyde Park, Battersea Park and elsewhere. Not long after he began cycling he had some major difficulties to overcome in his personal life. The bike and cycling helped him to overcome the problems: it became his personal therapy, and he's never looked back. He now has his eye on a second bike.

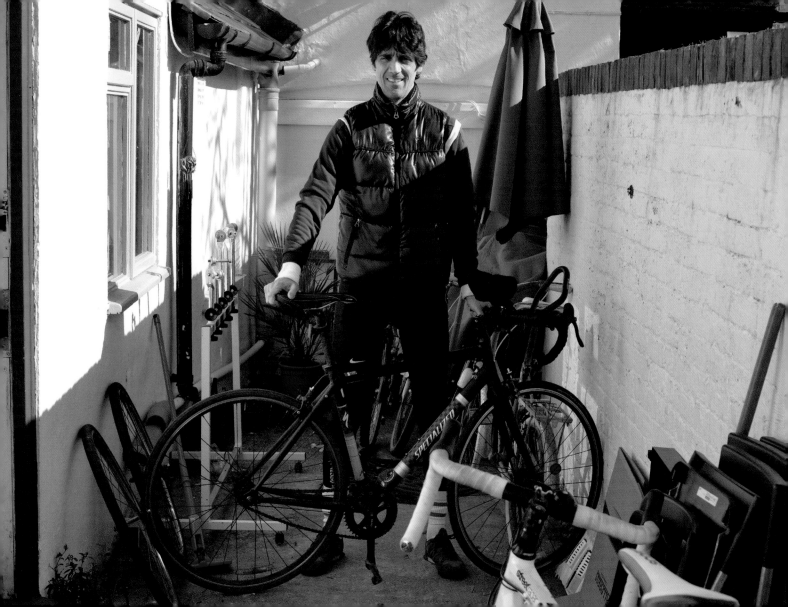

## **Mitchell Thomas** Ex professional footballer
### *Specialized S-Works Hardtail Stump Jumper*

Mitchell played for Luton Town, Spurs and West Ham but when he retired from 'the beautiful game' he still wanted to maintain a high level of fitness. He didn't want to go jogging so a friend of his got him into cycling. Even though he considered himself quite fit, he found that cycling was a completely different kind of discipline and, at first, he found it hard to keep up with his cycling buddy. "I try to get out at least three times a week if I can. More when the weather is better. On a normal Saturday I often do about 60 miles on the road, on a round trip. On Sunday I use the mountain bike – a lot of technical riding. I like to push myself hard, averaging about 30 miles." He has two other bikes, a Pinarello Prince and a Pinarello Dogma, and is pretty serious about his cycling. He has ridden in Portugal and France and intends to do the London to Paris in future.

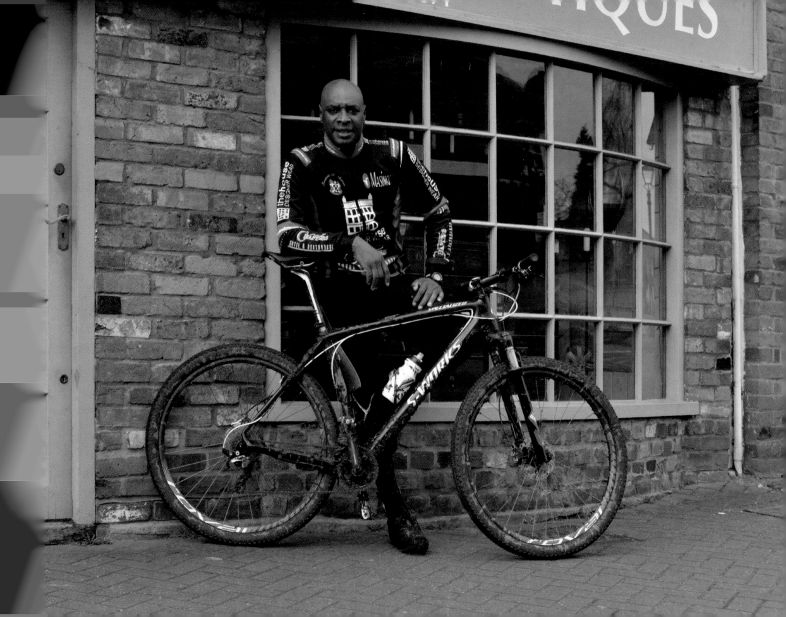

## Tom Mitchell Roving printer on a bike
*Specially modified road bike, with old mangle*

Tom runs a project called The Culture Cart, which is a community-engaged mobile print workshop. It is all based on what he can carry around on his bike. He encourages the public to have a go at lino-printing too. he began the project in November 2012 and it was initially funded by Southwark Council in London. He plans to travel all over the UK with his Culture Cart and perhaps even into Europe.

## Revd Kenneth Padley Vicar of St Michael with St Mary
*Specialized Crosstrail 2013 XXL*

Kenneth learnt to ride rather late by schoolboy standards because his parents were worried by the amount of traffic on the roads at the time. He was over 10 when he got his first bike, given to him by his half-sister. As a teenager he had a couple of nondescript machines, cheap and heavy, but they did enable him to get out and about. While at Oxford University, bikes were the only sensible mode of transport, so he cycled all of the time. After university, he got a job in Dulwich, and again, cycling became a practical solution. Now that he has been ordained, Kenneth still regards cycling as a simple and cheap way of seeing his parishioners.

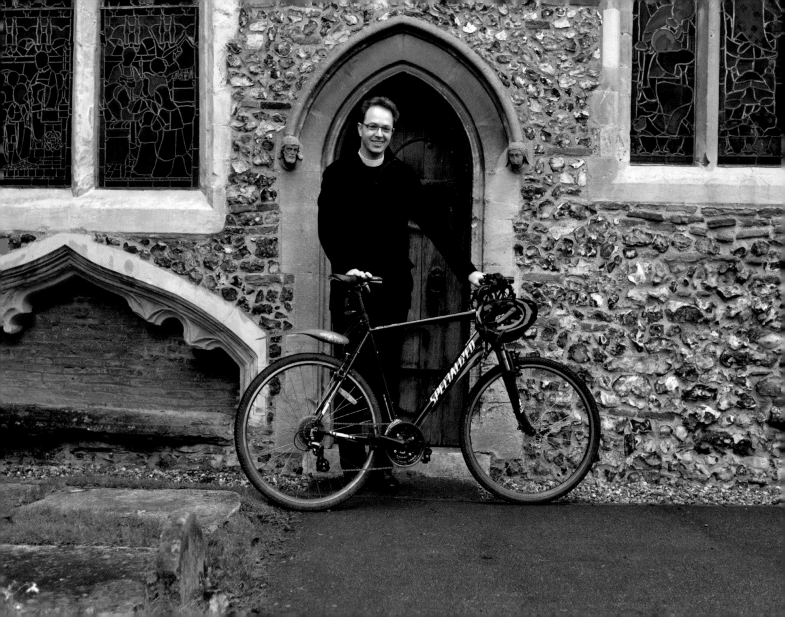

## Laura Pitts Headhunter
*Viscount Prelude*

Laura recalls that, as a six-year-old, she had a bright pink Raleigh cycle. Her dad took her out to the local park with the bike fitted with stabilisers. After a few 'goes' learning to move along, he removed the stabilisers and so began her two-wheeled journey. She says "Dad used to run along beside me, holding the saddle, and I felt very secure. But then, suddenly I turned around and Dad was a long way away. I had ridden quite a distance by myself! That was a proud moment."

Laura's next cycle was a purple mountain bike. She had asked for this as a present, but her (cruel) father said that if she really wanted it she'd have to save up for it. To her great and lasting credit, Laura did save up pocket money and got her dream bike. Since then she has remembered the lesson as she is now a thrifty young woman.

The present machine was donated to Laura by a neighbour. It's exactly what she wanted and is perfect for shopping around town.

## **Robert Wiltshere** Purchasing Director
*Specialized Roubaix*

When Robert's daughter began attending Sunday school, a group of dads decided to use the couple of hours they had free to get some exercise, so they began a cycling group. Robert didn't have his own machine at that point, so bought one at an auction being held in town. He decided to ride his purchase home, and after about a mile or so, thought he was going to die! Gradually, however, he persevered and got slowly fitter. Then he could go for long rides, and just be with his thoughts, or he could ride socially with friends. Cycling thus became an essential part of his life.

His friend, a doctor, came for dinner one evening and proposed a cycle ride to the coast. He had worked out that the nearest point was Maldon in Essex. The pair cycled to the town, which was less exciting than anticipated. However their rides gradually became more ambitious, and they raised a fair amount of money in support of the British Legion. However, in the end, the cycling group decided that they couldn't keep asking people to support them financially, and decided to fund their own annual cycle rides, usually in France.

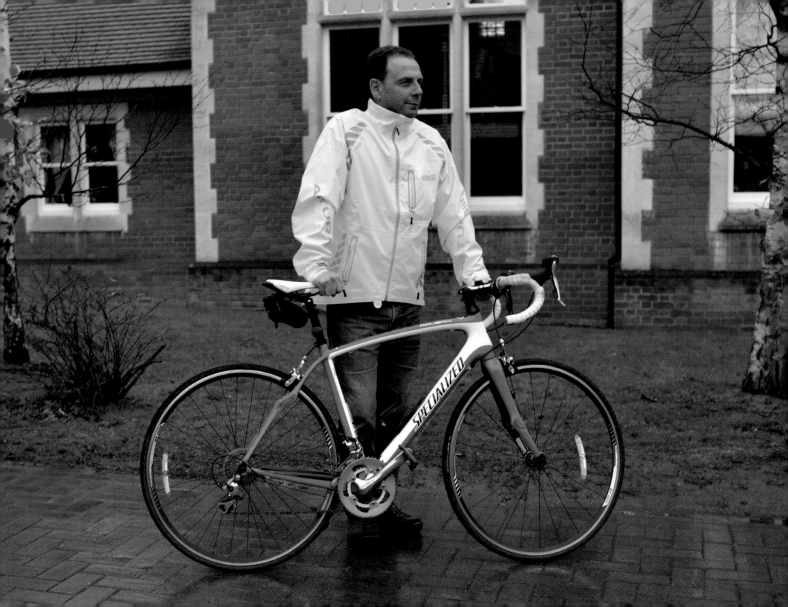

# Ben Morris
*2013 Specialized Roubaix*

Ben is proud of having completed his first triathlon in 2012 at Dorney Lake. It all began when a work colleague threw down a challenge which he was unable to resist. So began a great deal of hard training. Before all this, he had never ridden a road bike and so everything had to be learnt the hard way. Although he had ridden as a youngster, and was very much into mountain bikes, road work proved to be harder than he expected. However, he found that he really liked the 'magic' of being alone on the endless road and enjoyed it immensely. He also finds competitive riding stimulating. He feels that now that he has discovered this side of cycling, he will always carry on with it.

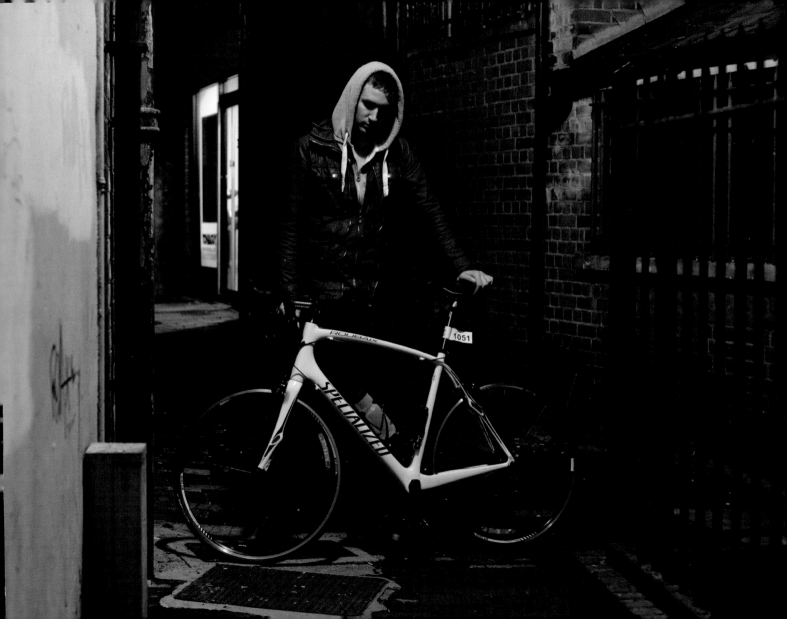

# Simon Godwin
*Merida 904 Sculptura 2013*

The Merida is Simon's first road bike. It is one of a line of previous bikes, but this machine has been specifically chosen for road work. He has been cycling around London, mostly in connection with work, for about six years or so. The amount of cycling has been steadily increasing, especially at weekends. Eventually, he decided to take part in some events, so training was stepped up. His good friend suggested that Simon compete in the Argos race, beginning in the centre of Cape Town, going down the east coast to Cape Point and back up the west coast, through Chapman's Peak, finally ending in Cape Town.

"It's incredibly beautiful countryside, and it's also quite nice to cycle in ambient temperatures above 2 degrees Celsius!" he says. "The race is approximately 110 km, so it's quite punishing for the unprepared." Apparently the race is the largest measured bike ride in the world, with about 35,000 cyclists competing. It needs military style organisation to make the ride a complete success. Simon is now keen to do more and has booked himself for The Circuit of the Cotswolds later in the year. No doubt more rides will follow.

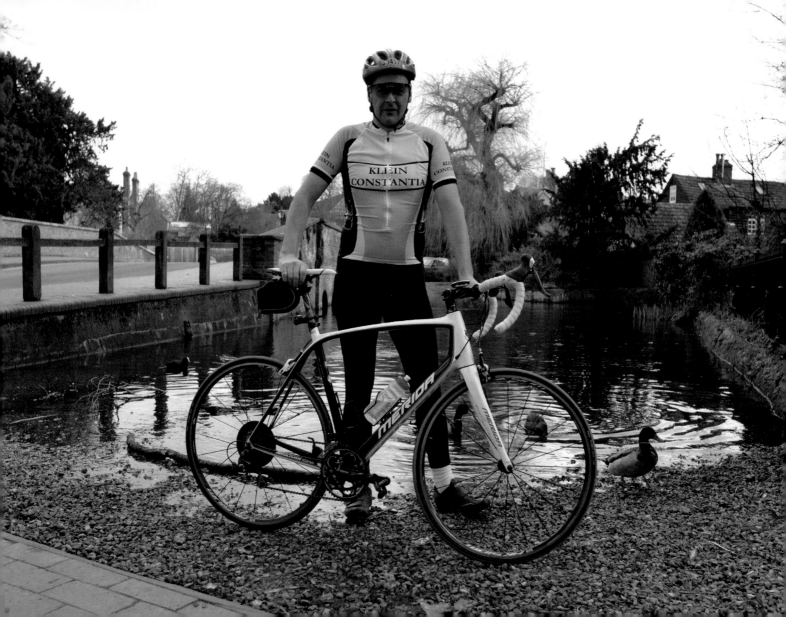

# Dr Bruce Cavell G.P.

*Trek road bike*

"I bought it off the internet. It's my first metal bike – I don't like those plastic things! I have ridden it to Paris. I have ridden it to Brussels. It's been to Nice. My friends keep trying to persuade me to have a carbon fibre bike but I keep resisting. I love this bike – it's seen me through thick and thin. Aluminium is perfectly good. I have had the machine for five or six years, and it's a jolly good bike!"

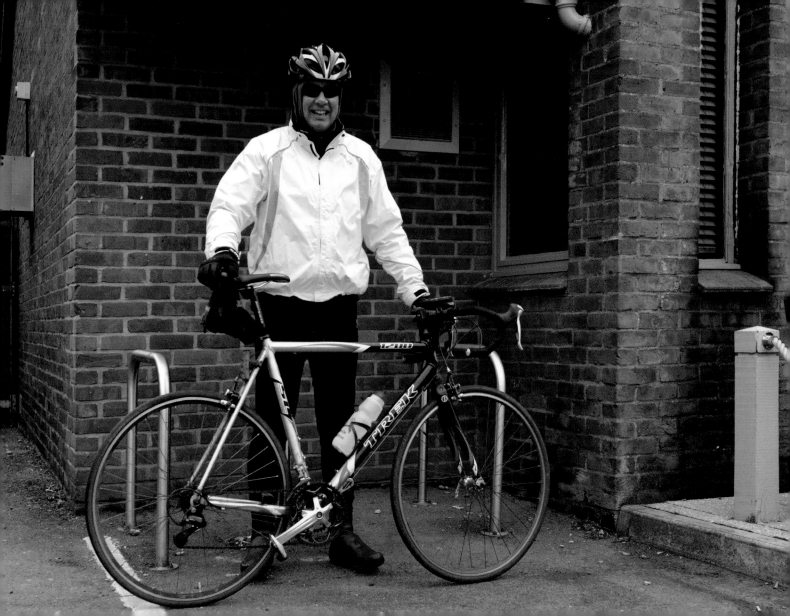

# Freddy Cook Part-time Book-keeper,
training to be Science Teacher
*Chas Roberts road bike, Columbus tubing*

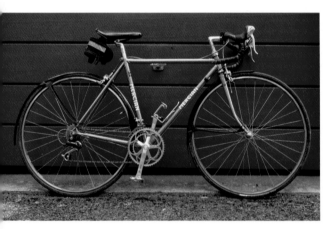

Freddy is currently building his own bike; he has bought the frame, which was made by Frederick Pratt, and is gradually acquiring the various components he needs. He has an immediate affinity with the machine he's building as he shares the maker's name. He is aiming for a retro-classic ride with which to explore the surrounding countryside. He has managed to source almost all the parts, but hasn't yet been able to decide which wheels to use. "I want the bike to look right" says Freddy, "I tried some deep section rims, but that wasn't it."

The Roberts bike in the photo was bought from a man in Chesham, Bucks. He, in turn, had been building it for a friend who then died, so the bike was in need of a new owner. Freddy felt honoured to fulfil that need. He loves riding the bike as it is built for comfort.

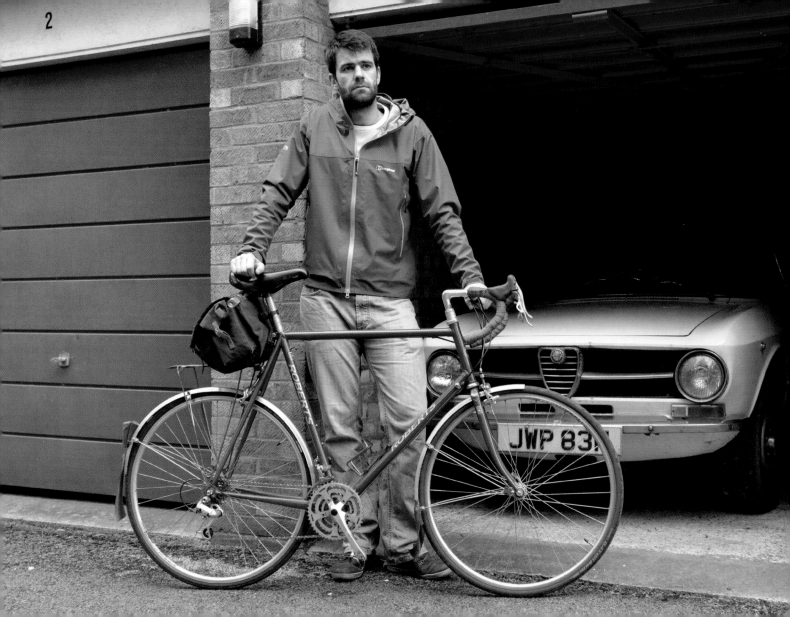

## Skippy Cheese Employed by the Metropolitan Police
*Scott Scale 40 electric bike, hub motor*

The bike shown in the photo is a tough, mountain bike fitted with a motor in the rear hub – the battery fits in the rider's rucksack. It was originally bought through the 'Cycle to Work' scheme about five years ago. "I was looking for an all-rounder bike" says Skippy, "I wasn't particularly in need of dual-suspension, but the bike had to be capable of riding on-road and off-road." The bike has a range of about 20 miles, but it can still be pedalled, and it has a top speed of 30 mph.

His very first machine was a trike, made of plastic, which was styled like an American motorbike. This lovely machine gave him an early taste of freedom. But his first real bike was a BMX; he thinks it was a Raleigh Falcon. He was always keen on tough sports and wanted to fit in with his friends. So the BMX was a great bike for going on adventures. He wasn't allowed to go far from home or cross major roads, so Skippy and his mates used to ride up and down a 100m stretch of pavement outside their houses, much to the annoyance of some of the neighbours. He remembers making jump-boards from which to practice leaping off into space.

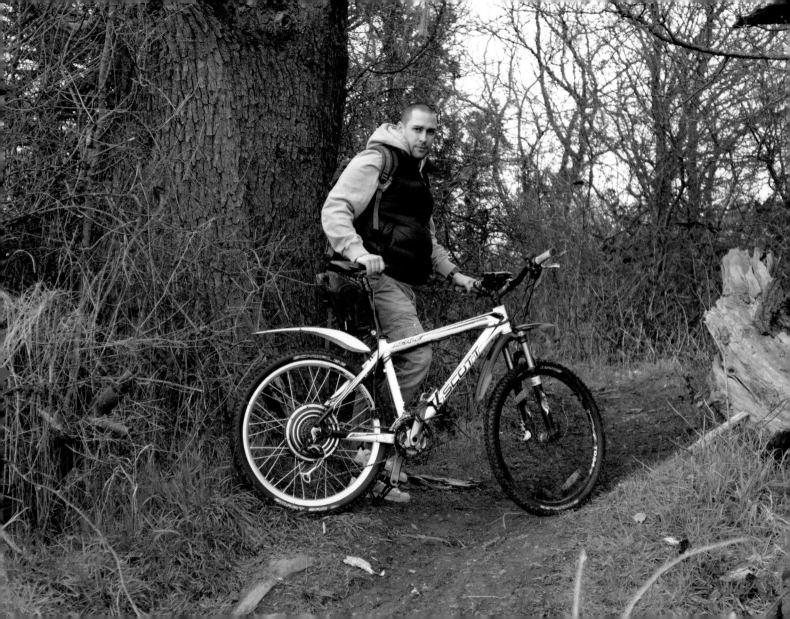

# Richard Harpham Adventurer
*Salsa Mukluk "fatbike"*

Richard's bike is an American machine designed for use on snow or sand. These bikes are becoming more widely used around the world now as more people discover the efficacy of having a four-inch tyre on sand or snow. He does a lot of sea kayaking and cycling in remote places; he calls it 'human-powered adventure'. One example was when Richard hiked in Alaska following the route of the original 'Gold Rush', which confirmed his great admiration for those tough men who walked, carrying heavy equipment, in pursuit of their dreams.

"When you're on a bike, in some remote location, you get to see so much more of the country than if you're in a car; people treat you differently; they offer you food; offer you drink; it's an altogether rewarding experience," says Richard. "When we cycled over the Atlas mountains, lorries were hooting, people were waving, and it was all an incredible buzz." He loves the 'magic moments' on journeys. For instance, he was kayaking in the sea recently when he was suddenly surrounded by seals playing in the water around him.

When Richard's job ended and he was forced to re-evaluate his life, he walked 100 miles on his own in order to be able to think clearly. He decided that he would look at the world around him in a different way. He wanted to inspire others, particularly the young. So began a series of big trips: London to Marrakech, which was a mix of cycling and kayaking over 47 days covering over 2000 miles; in Morocco he cycled extensively; he then decided to cycle through the Sahara in order to really put the fat bike through its paces. It turned out to be a 370 mile ride. It never stops with Richard; before he's finished one adventure, he's already planning the next one.

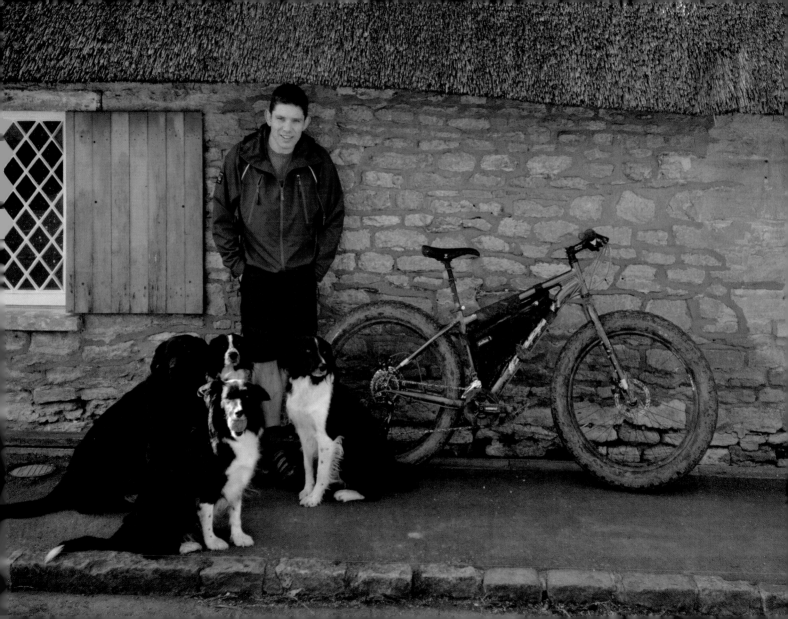

# Joe Singer
*HyperSport carbon fibre recumbent bike*

Joe's interest in bikes began when he used to go out riding with his father and friends, then he attended a frame-making course as a young man. He loves riding this machine – it's very light, comfortable, fast and aerodynamic and he can't understand why these bikes aren't much more popular. He has always enjoyed mechanical things; he is very adept at taking things to bits and enjoys the craft of creating with his hands. For a long time he wanted to be an engineer, and ended up doing an apprenticeship at Ford Motors which gave him a good basis for working on cars, which has been another of his passions.

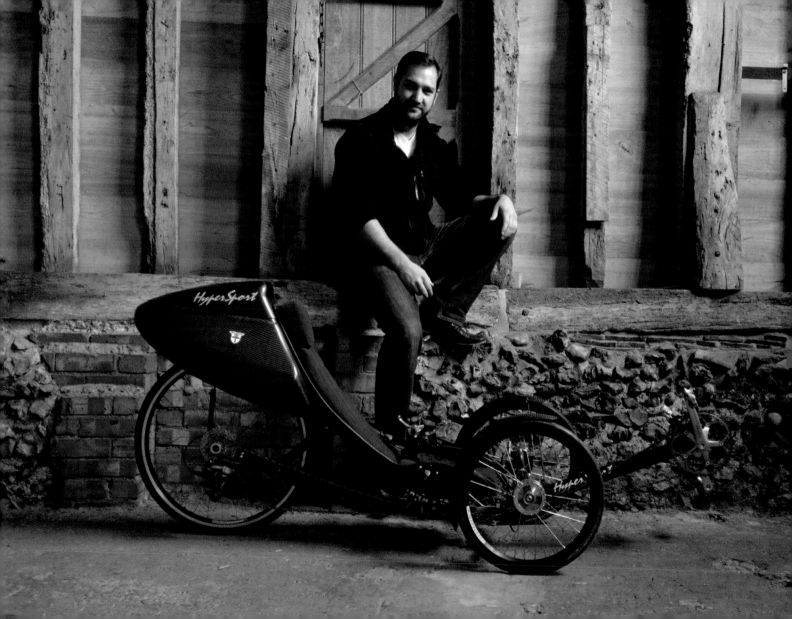

# Dr Simon Leadbeater

*Pashley Sovereign Princess*

Simon had always wanted a British-made bike, but several years ago he had a hip replacement, which meant that having a crossbar would make mounting difficult; so he opted for a ladies 'Princess'. The bike comes with a basket on the front, but Simon thought it made the machine look too feminine, so he added the panniers, partly for balance and partly to make it a little more masculine. He now finds it ideal for shopping trips around town. He really got into cycling whilst at Oxford Brooks University, when he discovered just how useful a bike can be. Then there was a gap in his cycling career until he got himself the Pashley. For a while he also had a Claud Butler, but that ended up with his father.

Simon's hard hat (by Moody and Farrell) deserves a special mention: it was made by the milliner Eloise Farrell and is known as 'the Sherlock' (for obvious reasons). This particular hat was the last one made by Eloise, as she had previously made them for Bobbins Bicycles, who now only sell bicycles wholesale. Her grandfather, who always wore a hat, had the surname Farrell. She wanted to name her company after him, hence Moody and Farrell.

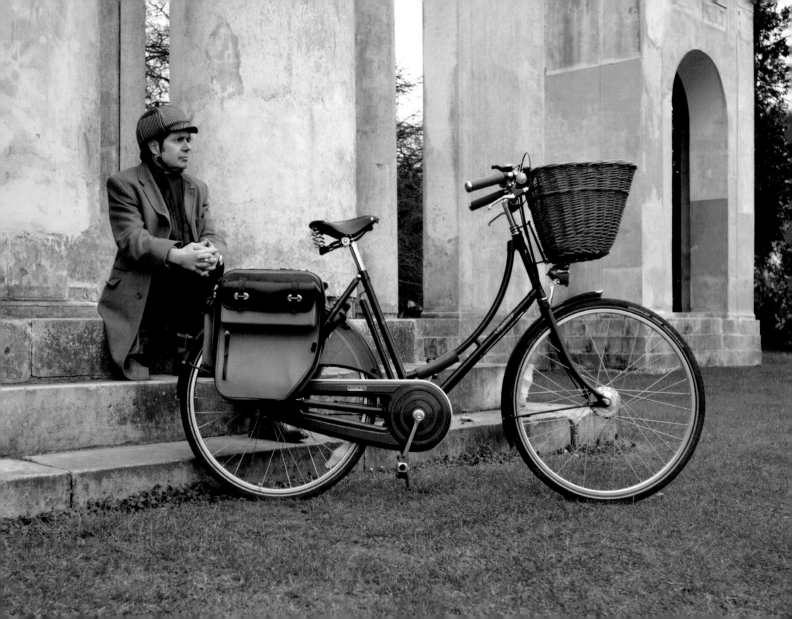

# **Dave Keeler** Retired Development Engineer
*Second-hand racer*

Despite the ordinary bike shown in the photo, Dave's career in cycling has been long and eventful. He began racing in 1946 while still at school in Letchworth, Hertfordshire. The school had no cycling club so the pupils had to organise their own time trials. At this time he had a Raleigh Sport which cost about £5. As he developed as a cyclist he began to enter some time-trials, for which he needed a better bike, so he got himself a Hetchins fixie. When he moved on to Nottingham University, he again joined the cycling club there and went on to represent England in 1949 at the World Student Games in Budapest.

Dave was a lifelong vegetarian, so he joined the VC&AC which gave the club a much needed boost in the period after the war. One day he rode from his college in Nottingham all the way to Derby in order to visit Mercian Cycles. It was a decisive point in his career as he went on to race Mercian bikes for the rest of his time in competitive cycling.

In 1951 Dave lowered the 25-mile trial record twice as well as taking the 30-mile record. He was the first rider to beat the hour in Wales, and was also the Scottish 25-mile champion. He even beat the Welsh 50-mile record for good measure. On the track, he managed to acquire the NCU 4000 metres Pursuit Title at the Butts Stadium in Coventry.

By the late 1950s he was doing extraordinary mileages and raced in the UK and on the Continent, culminating in two consecutive victories in the North Road 24-hour event. He continued to enter as many races as he could manage until about 1962 after which he did very little competitive work, instead

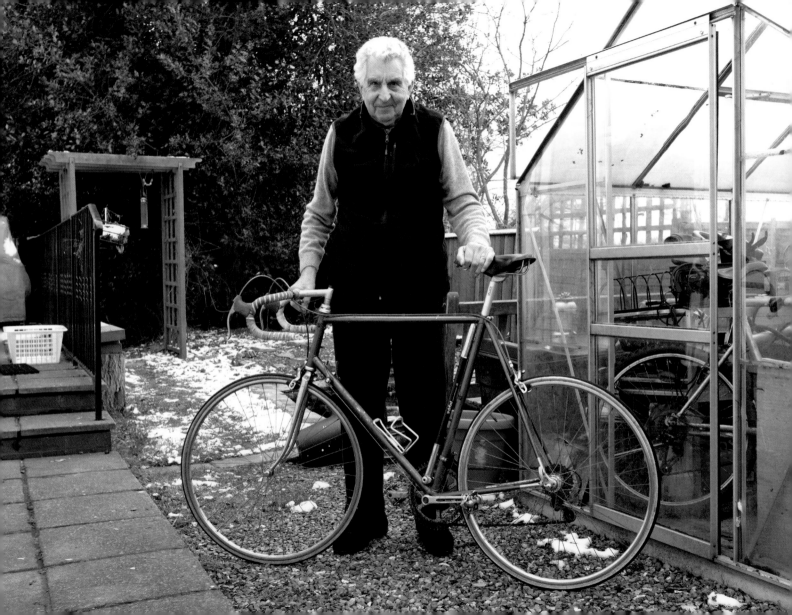

entering the odd event, and concentrating on cycling for pleasure. He has won over 100 open events, and was under an hour almost 50 times in the 25-mile events; in 1951 he even finished third in the National 50-mile Championships using a 'Constrictor' gear he had machined and built himself.

Here he is, 'waiting for the go.'

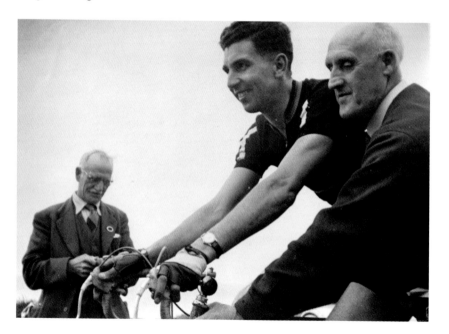